Italian Baroque Drawings

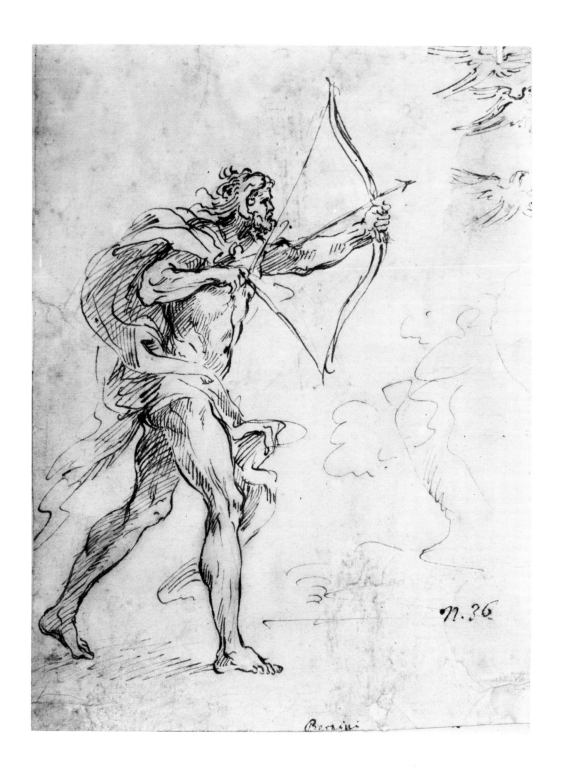

n.36

Bernini

British Museum Prints and Drawings Series

Italian Baroque Drawings

Nicholas Turner

A Colonnade Book

Published by British Museum Publications Limited

Colonnade Books
are published by British Museum Publications
Ltd and are offered as contributions to the
enjoyment, study and understanding of art,
archaeology and history.

The same publishers also produce the official
publications of the British Museum.

British Library Cataloguing in Publication Data

Turner, Nicholas
 Italian baroque drawings. – (British Museum.
 Prints and drawings series).
 1. Drawing, Italian
 2. Drawing, Baroque – Italy
 I. Title II. Series
 741.9'45 NC255

ISBN 0-7141-8025-4

Published by British Museum Publications Ltd,
6 Bedford Square, London WC1B 3RA

Designed by James Shurmer

Set in Monophoto Sabon and printed in Great
Britain by Butler and Tanner Ltd, Frome and
London

Jacket: *Boy angel playing a violin* by Annibale
Carracci

Frontispiece: *Hercules shooting at the
Stymphalian Birds* by Alessandro Algardi

Contents

Acknowledgments

I should like to thank Mr J. A. Gere, Keeper of the Department of Prints and Drawings, for reading through the text of the introduction and making many valuable suggestions.

Italian Baroque Drawings

The collection of Italian Baroque drawings in the Department of Prints and Drawings of the British Museum, though not as large as those of the Louvre, Windsor and Düsseldorf, is unusually representative, including choice examples of most of the greatest artists of the period. This book assembles a number of these, which show the development of Baroque drawing especially in Rome but also in other artistic centres: Bologna, Florence, Genoa, Venice and Naples.

There is an evident bias in the collection towards finished composition drawings and figure studies; rapid sketches, architectural and ornament drawings are comparatively less well represented. This is a reflection of the taste of English connoisseurs of the past, from whose collections that of the British Museum has been largely formed and who tended to prefer the carefully considered pictorial qualities of the finished drawing.

The essentially selective character of the collection is shown by the absence of the large groups of drawings by any single artist such as exist, for example, at Windsor for the Carracci, Domenichino and Carlo Maratta; at Düsseldorf for such Baroque masters as Maratta, Sacchi, Gaulli, Guglielmo Cortese, Passeri and Calandrucci; and in the Louvre for the Carracci. Such groups, mostly of chalk studies from the life for figures to be employed in paintings, and which usually came from an artist's studio on his death, often represent a significant proportion of his entire surviving output of drawings. Their presence at Windsor and Düsseldorf and in the Louvre accounts for the special importance of these great collections. In the British Museum the sole exception to this is a group of some 124 drawings by the minor Bolognese landscape painter Giovanni Francesco Grimaldi (see no.47).

With the purchase of Sir Hans Sloane's collection in 1753 the Museum acquired some Italian seventeenth-century drawings, though they were only a small part of a very large collection of drawings of the major European schools. Furthermore, their quality was not equal to those of the Italian fifteenth and sixteenth centuries which had been more systematically collected. A more representative selection of Italian Baroque drawings came in 1769 with the bequest of William Fawkener, but even with this addition the Museum's collection in this field remained small. Significant groups of drawings by some major painters such as Annibale and Ludovico Carracci, Guercino, and Salvator Rosa arrived with the bequests of the Rev. Clayton Mordaunt Cracherode and Richard Payne Knight in 1799 and 1824 respectively.

Until recently in the history of the Museum, Italian drawings of the fifteenth and sixteenth centuries have been considered more desirable than those of the seventeenth. The nineteenth-century critical prejudice against the Baroque as a 'decadent' aftermath of the Renaissance accounts for this neglect. The most important single group of Italian

drawings to enter the Museum in the later nineteenth century, the magnificent collection of John Malcolm, purchased in 1895, was relatively weak in seventeenth-century drawings. Malcolm aimed above all to illustrate the Italian Renaissance; and though a few well-chosen examples of seventeenth-century drawing were collected, this was only to summarise the later development of the major Italian Schools. It is, of course, understandable that at a time when Renaissance drawings of the best quality were still to be had a wealthy collector would prefer to buy these rather than crowd his collection with Baroque drawings, then in plentiful and inexpensive supply, which had not yet become the subject of serious study. Charles Ricketts, a *fin-de-siècle* connoisseur whose taste was both exquisite and highly catholic, made a significant comment in his journal in 1902 about the destruction by fire of a French eighteenth-century collection: 'Think, *allowance being made for tons of Carracci drawings* [my italics], what a collection made by a rich artist had the chance of being!'

By far the largest group of Italian Baroque drawings to enter the Museum, increasing their previous representation by at least a third, was added only quite recently, in 1946, when the Phillipps-Fenwick Collection was presented to the Department. This collection was assembled by a near contemporary of Malcolm, the famous bibliophile Sir Thomas Phillipps. His attitude to collecting was quite different, however: whereas Malcolm had made carefully selected purchases, mostly through dealers, and was highly dependent on his expert adviser Sir Charles Robinson, Phillipps bought in bulk directly in the sale-room. His motives for collecting drawings at all are far from clear, since his principal interest was the accumulation of books and manuscripts; certainly his method of acquisition and his classification of drawings once they had reached his collection were less systematic than Malcolm's had been. So much so, indeed, that the bulk of the collection remained in the wrappers in which the drawings had been offered in the sale-room. He bought the great majority of the drawings at the sale, held at Christie's in June 1860, of the residue of the Lawrence Collection of which the Phillipps-Fenwick Collection constitutes the largest surviving fragment. The purchases seem on the whole to have been made quite indiscriminately and to have consisted of the cheaper, mixed lots. But many of these turned out to contain pieces of great importance, and it is with the acquisition of the Phillipps-Fenwick Collection that many of the lesser artists of the seventeenth century, who had previously escaped attention, came to be represented in the British Museum for the first time.

The Baroque style, as compared with the previous style known generically as 'Mannerism', is characterised by a greater naturalism which, in the work of many artists of the period, is linked to an attempt to recapture the sense of solid form of classical sculpture. Although it might be supposed that the painterly qualities which are a feature of the Baroque would make it unsympathetic to the 'rational' discipline of drawing, this is not the case, and the traditional use of drawing as a preparation for painting or sculpture, or as an activity undertaken in its own right, flourished to such an extent that vastly more drawings have survived from the Baroque period than from any previous period of Italian art. Indeed, the change from the contrived stylishness of Mannerism towards a greater naturalism encouraged the making of studies from the life as a preliminary to painting, since this was an obvious way for the artist to confront nature and to achieve realism. It is no coincidence that landscape drawing also developed significantly at this time, and that landscape sketches were often made not in the studio, as had usually been the case, but directly from nature in the open air. The tendency towards a monumental naturalism in painting became fully apparent in the mid-to-late 1590s in the Roman works of the Bolognese painter Annibale Carracci, and culminated with his decoration of the ceiling of the Gallery of the Palazzo Farnese, completed in 1600. Here the naturalistic colour of North Italian Renaissance painters, such as Correggio, Titian and Veronese, is combined with the monumental form of the Antique and of the Roman High Renaissance masters, especially Raphael and Michelangelo.

The novelty of Annibale's painting is paralleled by that of his drawing. Fundamental to his working method was his revival of the practice used by Raphael and Michelangelo of drawing from the life to prepare the pose of a figure to be used in a painting (for his earlier Bolognese style, inspired by Correggio, see below, p. 13). His many drawings of this kind, combining as they do solidity of structure and economy of means, differ from those of his High Renaissance predecessors in their more vigorous technique and greater truth to life. They were a model to his principal followers Guido Reni, Francesco Albani, Giovanni Lanfranco and Domenichino, all of whom adopted and were responsible for disseminating his particular methods of composition and style of drawing.

The *Cartoon of a helmsman* (1), a typical example of Annibale's broad technique of figure drawing, represents a late stage in the preparation of the painting for which it is a study. His pen-and-wash drawing *The Drunken Silenus* (2) resembles compositionally the disposition of figures in an antique relief and shows formal characteristics, particularly in the angular rendering of the facial features of the figures, that seem to depend on Raphael's drawings.

Annibale was a teacher who provided his pupils with a systematic and readily assimilable working method in which drawing played a crucial role. But the other great painter who broke away from the conventions of Mannerism at roughly the same time, Michelangelo Merisi da Caravaggio (1573-1610), was not interested in instructing his followers. Caravaggio appears not to have made drawings at all – at least, none has

survived which is generally accepted as his. He preferred to bypass this preparatory process by working directly on to the canvas, and this became the practice of his followers.

The succeeding phase in the development of painting and sculpture in Rome, between c.1625 and c.1660, is dominated by two competing styles: Full Baroque and Baroque Classicism. As their respective representatives, Pietro da Cortona is ranged against Andrea Sacchi in painting and Gian Lorenzo Bernini against Alessandro Algardi in sculpture. Like all such divisions this is largely an artificial one and should not be too rigidly applied. The stylistic differences often evident in the paintings and sculptures of the two factions are not so marked in their drawings, all of which share, to a greater or lesser degree, a common source of inspiration in those by Annibale Carracci.

The most important painter of the Roman Full Baroque was the Tuscan Pietro Berrettini, called Pietro da Cortona, whose early training took place in Florence, but whose career was mainly spent in Rome. Prolific as a draughtsman, his drawings show a combination of two major influences: Annibale's late drawing style and that prevalent in Florence around the turn of the century, especially as exemplified by Ludovico Cardi, called Cigoli (1559-1613). No. 13, the *Half-length figure of a woman carrying the fasces on her shoulder*, a preparatory drawing for a figure in the ceiling fresco of the great hall of the Palazzo Barberini, Rome, well illustrates the first influence, showing Cortona studying from the life the pose of a figure intended as part of a large, complex decoration; but the technique is freer than similar drawings by Annibale. The second influence may be detected in Cortona's fluent pen-and-ink drawings (see no.14), which are often full of changes and corrections. Rapid sketches, though less experimental in approach, exist by Cigoli in this medium, where there is a similar disregard for the effect on the drawing of changes and cancellations.

Cortona was the head of a large studio, but his assistants rarely showed great originality even when they had left their master's immediate orbit, being content to perpetuate his style with little variation in their own work. These, the 'Cortoneschi', include Giovanni Francesco Romanelli, Giacinto Gimignani, Ciro Ferri and Lazzaro Baldi. The contemporary success of their work reflects the popularity of Cortona's style, and their activity was an important element in Roman painting in the second half of the seventeenth century. The only painter to have trained for any length of time with Cortona and to have developed a truly independent style was the French-born Guillaume Courtois (Guglielmo Cortese); but his individual technique was developed principally under the influence of Gian Lorenzo Bernini for whom he worked in the 1660s.

The Baroque Classicism of Andrea Sacchi conflicted with Cortona's High Baroque style in many of its aims. Sacchi's disciplined approach to painting and drawing depended to a great extent upon the example of Domenichino, who had developed an academic variation of Annibale's late style. Another important influence, that of Raphael, is recorded by Sacchi's biographers. No less than Cortona, Sacchi was also influenced by the drawings of Annibale Carracci, but the results were entirely different.

Gian Lorenzo Bernini, whose brilliant career as a sculptor and architect spans almost sixty years, was a draughtsman of genius. His drawings possess a hurried directness, a typically Baroque vigour which matches that of his sculpture. This spontaneity can be seen in his preparatory study for the Beaufort catafalque (9) where the seemingly haphazard flecks of wash on the pyramid subtly evoke the shining surface of marble. In the late self-portrait (10) chalk is used not so much to delineate forms as to suggest patches of shading, with the result that the head is modelled sculpturally by means of a series of delicate tonal sequences.

The drawings of Alessandro Algardi, the other great Roman sculptor of this period, are less varied in technique. Often in pen and wash over black chalk, they have an elegance of line and a flatness of form which reveal the influence of his teacher, Ludovico Carracci. The persistence of Ludovico's style in Algardi's drawings can be recognised in the study for *Hercules shooting at the Stymphalian Birds* (11). When Algardi's drawings attain a stronger degree of plasticity, towards the end of his career, it is through the influence of his friend Pietro da Cortona.

Two artists, both of whom studied briefly with Pietro da Cortona and who were both later influenced by the French painter Nicolas Poussin (1594-1665), should be mentioned here: Pietro Testa and Pier Francesco Mola. Testa, a melancholic of difficult character, failed to establish a reputation as a painter and turned instead to the making of etchings, executed with unusual care and diligence, and dense with esoteric symbolism that was denied expression in painting. Considering Testa's relatively small output of prints, a surprisingly large number of drawings by him has survived; these are austere in handling, usually in pen and ink over very faint underdrawing without the addition of wash (see nos.16 and 17). It may have been his neurotic temperament that attracted him particularly to drawing, which provided him with an absorbing activity and enabled him to express grandiose ideas that could not readily be translated into other media.

Mola was more diverse as a draughtsman, and his pictorial approach to drawing was quite different from Testa's precise style. *The Expulsion* (20) shows his original and fluent use of brush drawing with wash. Here, as in a painted sketch, figurative form is not so much accurately described as hinted at with summary strokes of the brush. The spectator must therefore use his imagination to visualise the realistic image that the artist merely suggests. His favourite combination of black and red chalk with pen and brown wash conveys a range of colour wider than that of the actual materials (see no.19).

The conflict in the first half of the seventeenth century between the two opposing styles in Roman art continued into the second half of the century with a new generation of artists. Giovanni Battista Gaulli, called Baciccio, practised a Baroque style of painting which contrasted with the classical style of Sacchi's most successful pupil, Carlo Maratta. Gaulli's energetic and colourful paintings are often described as the pictorial equivalent of Bernini's late sculpture, and Bernini, who employed Gaulli in a number of decorative projects, certainly influenced his work. This influence is particularly

apparent in Gaulli's drawings which combine features derived from his Genoese background with devices used by Bernini, though these are handled with less flair.

The academic method adopted by Sacchi, with its roots in Annibale's use of life drawing, became an integral part of the technical procedure of his pupil Carlo Maratta, whose successful career made its use widespread. The number of Maratta's surviving drawings is immense; but they tend to lack something of the freshness of quality of those by Annibale, no less compulsive a draughtsman. Maratta's method of drawing was obviously based on Annibale's but became formalised to a point beyond which it failed to develop. The *Study for a figure of St John the Evangelist* (29), apparently the last in a series of life drawings for this figure, is typical of the type of study that Maratta produced in his mature period. He achieved greater spontaneity in his pen-and-ink drawings, which were mostly used to plan the compositions of his paintings (see no.30).

The principal developments in Italian Baroque drawing occurred in Rome, the theatre of activity of most of the major painters and sculptors of the period. Rome's artistic supremacy was a result of its position as the seat of the Holy See. Painters, sculptors and architects were required in large numbers for the construction and embellishment of churches and palaces in the city. To meet this demand Rome depended on a constant influx of artists from outside, for she herself, as in most periods of her history, was practically destitute of native talent. Of the great artists working there in the seventeenth century Sacchi alone was Roman by birth. Annibale Carracci came from Bologna, Bernini from Naples (though his father was Florentine), Cortona from Tuscany, Algardi from Bologna, and Maratta from the Marches. The majority arrived at a still formative phase of their training, and it was in Rome's unique artistic atmosphere that their development was determined and completed. Even Annibale, who was one of the few painters to arrive with a mature, personal style (and this is one of the explanations for his astonishing impact upon art in the city), was profoundly influenced by the special artistic atmosphere Rome provided.

Despite Rome's domination of the artistic scene, she did not always offer security to artists employed there. Her economy fluctuated considerably throughout this period and towards the end of the seventeenth century was in a state of decline. Patronage was erratic and often depended on the preference of the reigning Pope and his family for employing artists from their native cities. But the services of artists were in demand elsewhere in Italy, though the opportunities for fame and reward provided in other cities did not equal those in Rome. Bologna, Florence, Genoa and Naples were flourishing centres, each possessing their own distinct political traditions and each capable of offering steady employment to artists, many of whom were thus enabled to pursue their careers by remaining at home. Ludovico Carracci, for example, worked almost entirely in Bologna where the Carracci Academy continued to flourish after the departure of Annibale and Agostino. Carlo Dolci remained in Florence and was supported by the commissions he received from the Medici Court.

Other painters, and these were in the majority, though based elsewhere, were prepared to come to Rome whenever suitable commissions presented themselves. For example, the two Bolognese painters Guido Reni and Francesco Albani both spent many of their early years in Rome but in mid-career returned to Bologna for good.

Finally, there was still another category – the peripatetic artist whose travels took him to many different centres. An example at the beginning of the century is Caravaggio, who was active not only in Rome but also in Naples, Malta and Sicily (though it is true that his wandering career was forced on him by his difficult temperament and the necessity for keeping out of trouble). The phenomenon became more frequent towards the end of the century, as work became less readily available. Mattia Preti, although a native of Calabria, travelled as far afield as Rome, Bologna, Parma, Modena, Venice, Naples and Malta. Luca Giordano, though chiefly active in Naples, his birthplace, covered even greater distances, working not only in Rome, Parma, Venice and Florence but also in Madrid.

Of the artistic centres outside Rome, Bologna contributed most to the evolution of painting and drawing in the seventeenth century. As we have seen, it was there in the early work of Annibale and Ludovico Carracci that the new Baroque style first appeared. A feature of the new style was the making of many studies of the figure from the life in preparation for a painting. These studies were treated with a naturalism not seen since the High Renaissance. They were mostly in red chalk; their inspiration derived from studies of the same type and in the same medium by Correggio (1489-1534), who lived and worked almost entirely in the neighbouring city of Parma. Annibale's practice of 'academic' drawing led to the use of a wider tonal range and a more powerful monumentality. A good example of his drawings of this type is the study for a boy angel in his early *Baptism of Christ* (35).

The foundation by the Carracci in the early 1580s of an academy was an important landmark in Bolognese painting, for it ensured the continuation of the artistic reforms they had instituted. Indeed, its establishment coincided with the origin of a distinctive style of painting in the city. With Annibale's absence in Rome from 1595, the task of maintaining the Academy fell, first, mainly to his brother Agostino, until the latter's own departure for Rome in 1597, and then to their cousin Ludovico, until his death in 1619.

As a teacher in the Academy, Agostino Carracci played an important part, though as a painter and draughtsman he depended very much on Annibale's example. No. 36, *Landscape with figures by a river*, shows him following, but with a more meticulous handling of the pen, a style of landscape drawing frequently practised by Annibale. Ludovico Carracci had a more marked personality. So long as Annibale remained in Bologna, Ludovico's drawings, especially those in chalk, attained some of the realistic breadth of his cousin's. But this sense of form weakened after Annibale's departure, and a latent tendency towards an elegant linearism, which recalls Correggio's Mannerist follower Parmigianino (1503-40), became accentuated; this is particularly evident in

his drawings in pen and wash, a technique that he came more and more to employ. *Virgin and Child with Saints* (37) shows his refined, slightly flattened rendering of form and elegant feeling for line.

Ludovico's long period as head of the Carracci studio gave him a powerful influence on the drawings of a younger generation of Bolognese painters. This is apparent in many of those by his successor as the city's leading painter, Guido Reni, who shows his indebtedness in his early drawings – for example, in the *Coronation of the Virgin with four Saints* (39) – and throughout his career in his studies in pen and wash. As a draughtsman, Reni is principally known for his delicate chalk drawings with their characteristic broken line, as shown in the *Study for the head of St Crispin* (40). This staccato technique of drawing is largely Reni's invention; if a precedent were to be looked for, it might be found in the drawings in this medium not by Ludovico but by Annibale.

Simone Cantarini, though first a pupil of Ludovico, soon disassociated himself from his master's style and imitated that of Reni. His red chalk studies follow the latter's so closely that the drawings of the two have been frequently confused. Cantarini was also an etcher of distinction; no.42, *The Rape of Europa*, is a study for one of his prints.

If Reni's influence predominates in Cantarini's drawings, that of Ludovico is continued and developed in those of Giovanni Francesco Barbieri, called Guercino, who shortly after Reni's death in 1642 moved from Cento to Bologna where he soon became the city's leading painter. Guercino's output of drawings was immense, and their attractiveness made them widely popular throughout the eighteenth and even the nineteenth centuries, particularly with English collectors.

Like Ludovico, Guercino excelled in pen-and-wash drawing, but the more emphatic orchestration of his tone values made his portrayal of light more convincing. The play between extremes of light and dark gives his drawings their luminosity and unusual sense of space, for they are constructed almost entirely by tonal contrasts and hardly at all by the more usual devices of linear perspective found in many other drawings of the period. His attitude to line was also unconventional, particularly in his pen and pen-and-wash drawings, in which it seems to take on a wilful life of its own, often independent of any form-defining function. *Christ appearing to St Theresa* (46) is drawn with a web of delicate, meandering lines that are disciplined only when it is necessary to indicate the faces of the two figures.

The same feeling for tone found in Guercino's pen-and-wash drawings can also be seen in those in chalk – usually red rather than black. There the effect depends upon the contrasts between patches of carefully shaded mid-tone and, at the dark end of the scale, the more restricted areas of dark shadow when greater pressure has been exerted upon the crayon and, at the light end of the scale, the white of the paper (see nos.43 and 44).

The development of drawing in Florence in the period was less consistent than in Bologna, nor was it so influential on the evolution of drawing in Rome. Chief among

the group of painters working there at the beginning of the century was Cigoli, whose semi-naturalistic figure studies from the life, though often inspired by aims similar to Annibale's, failed to match his drawings in either quality or inventiveness. Academic drawing also continued in Florence where there was likewise an academy, the Accademia del Disegno, founded earlier than that of the Carracci in 1563. The later exponents of this academic tradition were Jacopo Chimenti da Empoli (1551-1640), Domenico Passignano (1550/5-1638), Francesco Curradi (1570-1661), Giovanni Biliverti (1576-1644), Cristofano Allori (1577-1621), Matteo Rosselli (1578-1651), Giovanni da S. Giovanni (1592-1636), Francesco Furini (1603-46) and Francesco Montelatici, called Cecco Bravo (1607-61). Rather than heralding any significant new development, their work marks the end of a tradition that had flourished in the city throughout the sixteenth century, beginning with Andrea del Sarto (1486-1530) and continuing with Pontormo (1494-1557) and Naldini (1537-c.1591). The widespread use of red chalk, particularly in the making of figure studies, was one of the strongest legacies of this tradition to survive into the seventeenth century.

The drawings of Stefano della Bella do, however, mark a new departure; their small scale and specialised purpose, though, tended to restrict their influence. Della Bella was primarily a print-maker, and in this activity he differed from most other artists of the period, concerned as they were with the production of large-scale painting and sculpture. His numerous prints, mostly on a small scale, have the same qualities of calligraphic fineness of line and realistic precision that characterise his drawings. He sometimes worked as a costume designer for operas staged by the Medici Court and its satellites, and no.50 is an example from a series of such drawings.

Carlo Dolci, active in the middle of the century, developed a highly finished technique of chalk drawing, often combining red and black chalk to produce a suggestion of colour. Such meticulously handled two-coloured chalk drawings had been made by several late sixteenth- and early seventeenth-century Florentine draughtsmen, and with particular success by Cristofano Allori. The late Mannerist painter Federico Zuccarro (1540/1-1609), who was in Florence on several occasions between 1565 and the end of his life and who was prominent as a member of the Accademia del Disegno, was, above all in his portrait drawings, attached to this particular technique and may have been responsible for introducing it to Florence. Nos.51 and 52, both of which are in black and red chalk, show how carefully Dolci worked and re-worked the sheet to achieve the same miniature-like degree of finish as he produced in his paintings.

Dolci's disciplined approach to drawing contrasts with the rapid and exuberant style of Baldassare Franceschini, called Volterrano, who was one of the most successful decorative painters of the period in Florence. Volterrano, like Dolci, was Florentine-trained and inspired by the early seventeenth-century tradition of Florentine painting, but by another aspect than the one that had absorbed Dolci, and his penchant for red chalk, sometimes enriched with pink wash and white heightening, is a characteristic that reveals his adherence to Florentine techniques of drawing. His elegant figures with their pointed, somewhat emaciated faces are to be found earlier in the paintings of

Cigoli, whose strong influence was transmitted to him through his master, Matteo Rosselli.

But the turning-point in seventeenth-century drawing in Florence was caused by the activity there, from 1640 to 1647, of Pietro da Cortona. Cortona's robust Roman style of drawing found an immediate following in Florence, and his influence was further strengthened after his return to Rome in 1647 by the intermittent activity in Florence of his close pupil, Ciro Ferri, who in the early 1670s was given charge of the newly founded Florentine Academy in Rome. The continuation of the Cortonesque style of drawing in Florence right up to the end of the seventeenth century was a consequence of the training of many painters and sculptors of the new generation under Ferri's direction at the Academy in Rome; these included G. B. Foggini (1652-1725) and Antonio Domenico Gabbiani (see no.55).

Like Florence, Genoa at the end of the sixteenth century possessed its own native artistic tradition. Genoese drawing at this period was inspired by the example of Luca Cambiaso (1527-85) whose heavily outlined pen-and-wash drawings, with figures often rendered in simplified 'cubist' forms, exerted an influence out of all proportion to their artistic merit. Cambiaso's pupils – for example, Giovanni Battista Paggi (1554-1627) and Lazzaro Tavarone (1556-1641) – were active in the city well into the first half of the seventeenth century, and their drawings show the indelible impact of their master's style.

The influence of the Cambiasesque tradition of drawing was modified by the impact of the work of two important visiting artists – the Flemings Peter Paul Rubens (1577-1640), who was in Genoa in 1607, and Anthony Van Dyck (1599-1641), who was there for periods between 1621 and 1627. Castiglione's use of oil sketching on paper, perhaps the most striking technical innovation in drawing to be practised by a Genoese artist, may have had its source in the rapid oil sketches on panel made by Rubens and Van Dyck (see no.56). But Castiglione's subject matter and types derive from another quarter, from Poussin and other mid-century classicising painters whose works he admired while in Rome, where he lived intermittently from 1631/2 to 1651. Indeed, many of these oil studies, with a finished quality, appear to have been made as works of art in their own right.

The leading Genoese painter of the second half of the seventeenth century was Domenico Piola, whose work, though somewhat pedestrian in style and feeling, exercised a strong influence on the artists of the following century. His drawings, often in pen and pale-brown wash, are somewhat bland and lack a sense of solid form; indeed, it was their very looseness and insubstantiality that appealed to the younger artists of the Rococo. Curiously enough, there is still a trace of Cambiaso's influence in Piola's preference for pale-brown wash and in his tendency sometimes to simplify the figure in geometrical terms. But also discernible is a facial type with enlarged eyes and bulging cheeks that he must have found in Van Dyck's pen drawings, where Castiglione had previously discovered them.

Venice in the seventeenth century was in a state of economic and political decline. Artistically, too, this was a fallow period, for it lay between the two great eras of Venetian painting: the sixteenth and the eighteenth centuries. The pictorial conventions of the Venetian Renaissance were continued into the seventeenth century, above all by Palma Giovane (1544-1628). The making of preparatory studies for pictures had played a relatively small part in the technical procedure of Venetian painters, and for this they had been criticised. But Palma Giovane, though a respectable painter in the manner of Tintoretto, was above all an obsessive draughtsman, as the enormous number of his surviving drawings shows. In his case, however, it is the activity that is remarkable rather than the elements of his style. None the less, there is no strongly coherent regional style of drawing in Venice in the seventeenth century; the practice of drawing as an important element in a painter's working procedure did not become widespread until the eighteenth century. The major painters working in Venice at the beginning of the century, Fetti (1589-1624), Lys (1595-1629) and Strozzi (1581-1644), seem to have been little concerned with drawing.

Two drawings (58 and 59), one by Giulio Carpioni, the other by Pietro Liberi, have been chosen to represent two contrasting styles of drawing in Venice in the middle of the seventeenth century. Carpioni was strongly influenced by Roman drawing, and no.58 is notable for its absence of Venetian elements. Liberi's style, on the other hand, is still strongly Venetian-based and reminiscent of sixteenth-century drawing, particularly that of Paolo Veronese.

In the first years of the seventeenth century Naples had no local tradition of drawing. In this respect it was less developed than the other centres previously discussed, which, even if they had not yet seen the Baroque style of drawing, had at least an earlier tradition of drawing inherited from the sixteenth century on which to build. The most significant artistic event to occur in Naples in the first years of the seventeenth century, the brief visit of Caravaggio in 1607, though decisive for the evolution of painting there, did not affect the development of drawing. It is true that two of Caravaggio's Neapolitan followers, Giovanni Battista Caracciolo (1570-1637) and Massimo Stanzione (1585-1656), made drawings, but these did not exert any significant influence on their fellow artists.

The development of Neapolitan drawing begins with the work of the Spaniard Giuseppe Ribera, who was undoubtedly one of the greatest draughtsmen of the seventeenth century. After visiting Parma and Rome, Ribera settled in Naples in c.1616, and his early paintings show him working in a Caravaggesque vein. His later work of the 1640s and 50s, on the other hand, in keeping with the mood of the times, is more classical, and is influenced by the Bolognese painters Annibale Carracci, Guido Reni and others.

Ribera's drawings are broadly of two types: finished drawings in red chalk (see no.60), where a wide range of tones is suggested by careful shading; and drawings in pen and brown wash, or in pen alone, where the handling is more rapid and nervous,

and the line often broken and jagged. The form of the figure in both types of drawings appears somehow flattened against the surface of the paper.

The next generation of Neapolitan painters was strongly influenced by Ribera's method of drawing: Salvator Rosa, in particular, adopted his staccato zig-zagging linear rhythms (see no.61). Ribera had provided Rosa with the vocabulary for the graphic exuberance of his *schizzi*, where accuracy in the delineation of figures is subordinated to the desire to record the expressive energy of the moment of creation. Whereas Ribera had maintained a rigid demarcation between his finished chalk technique and his more spontaneous pen and pen-and-wash drawings, Rosa in his 'creative fury' often combined the two media. His study for *Plato's Academy* (62) was first drawn with red and black chalk, before the mesh of pen-and-ink lines was superimposed.

Luca Giordano's early style of drawing was much influenced by Ribera, particularly his red chalk studies, such as no.64. Some of his early pen-and-wash drawings also come close to Ribera but they tend to have a greater breadth and a more monumental sense of form. In his late drawings, however, Giordano developed his own personal style. These were often drawn in black chalk and lightly washed with grey: the same sense of simplified, heavy form that characterises the figures in his early pen-and-wash studies is conveyed, despite the rapid execution. No.65 is an example of his late style; it is a preparatory study for a fresco in the church of S. Antonio de los Portugueses in Madrid. The fluent handling of Giordano's late drawings strongly influenced the following generation of painters in Naples – for example, Francesco Solimena (1657-1747) and later, and even further afield, a typically Rococo draughtsman such as Fragonard (1732-1806).

Though the drawings of most Neapolitan painters in the second half of the century show at least some influence of Ribera's drawing style, the principal inspiration behind the drawings of Mattia Preti, one of the greatest Neapolitan draughtsmen of the period, lies outside Naples. Early in his career Preti was in Rome, and it was there that he would have seen the red chalk drawings of Annibale Carracci, and of the classicising painters of the mid-century such as Andrea Sacchi; the influence of the drawings of these masters was decisive upon the formation of his graphic style. No.63, *Man carrying a barrel*, in many ways recalls the studies from the life made by the Carracci in Bologna at the end of the sixteenth century, but they seem refined compared with this drawing with its tough solidity and vigorous handling. However, a gentle lyricism is to be found in his much less common wash drawings.

The Plates

Roman Drawings

Annibale Carracci
Bologna 1560 – Rome 1609

1 *Cartoon of a helmsman*

Black chalk on grey paper.
443 × 459 mm; 4 sheets of irregular size joined
together, repaired.
Oo. 3-6.
Provenance: Lord Spencer (L 1531); Payne
Knight Bequest, 1824.
Literature: J. R. Martin, *Farnese Gallery*,
Princeton, 1965, p.246, no.28.

The figure appears at the stern of Ulysses' ship,
to the right of *Ulysses and the Sirens*, the
lunette-fresco in the *Camerino* of the Palazzo
Farnese, Rome. Annibale decorated this room
between 1595 and 1596/7, soon after his arrival
in Rome.

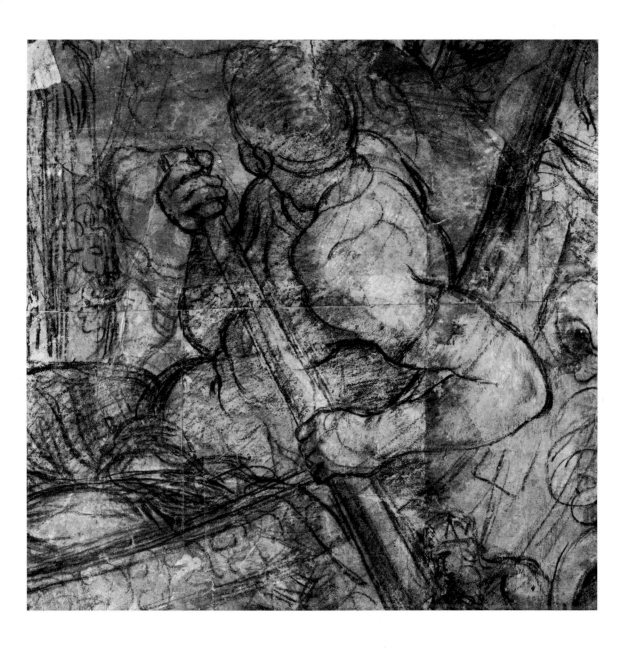

Annibale Carracci
Bologna 1560 – Rome 1609

2 *The Drunken Silenus: design for the 'Tazza Farnese'*

Pen and brown and grey wash over red chalk.
286 × 275 mm; made up with several sheets of
irregular size.

Pp. 3-20.

Provenance: Payne Knight Bequest, 1824.

Literature: D. Posner, *Annibale Carracci*,
London, 1971, vol.II, p.50, under no.113;
D. DeGrazia Bohlin, *Prints and related
drawings by the Carracci family* (exh. cat.,
National Gallery of Art), Washington, 1979,
under no.91.

In *c*.1598 Annibale made an engraving on silver
of this composition for Cardinal Odoardo
Farnese to decorate a silver cup known as the
'*Tazza Farnese*'. He was then at work for the
same patron on the decoration of the ceiling of
the Farnese Gallery. Although the cup itself is
lost, the engraved plaque survives (Naples,
Museo Capodimonte). The subject, Silenus
drinking, was clearly appropriate to the
decoration of such a vessel: Silenus, the oldest
satyr, is associated with drunkenness, music
and sleep. A further study for this composition
is in a private collection in London, another is
in the Metropolitan Museum, New York (both
drawings were formerly in the Ellesmere
Collection), and a third is in the Uffizi,
Florence; all three are reproduced by Bohlin.

Pen and wash is often used in composition
drawings made in the artist's Roman period,
and studies in the medium exist for parts of the
Farnese Gallery ceiling.

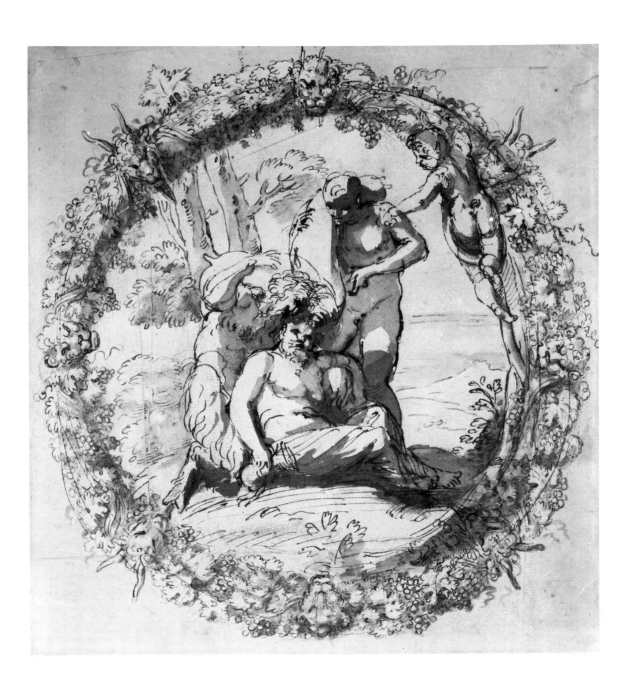

23

Annibale Carracci
Bologna 1560 – Rome 1609

3 *Landscape with the setting sun*

Pen and brown ink.

272 × 428 mm.

1972-7-22-13.

Provenance: Sir T. Lawrence; Lord Francis
Egerton, 1st Earl of Ellesmere (L 2710b).

Literature: P. Tomory, *The Ellesmere
Collection*, Leicester Museum, 1954, no.68;
Mostra dei Carracci: Disegni (exh. cat.),
Bologna, 2nd edition, 1963, no.247; D. Posner,
Annibale Carracci, London, 1971, vol.I, pp.113
and 172, n.6.

Numbered in brown ink in the lower right-
hand corner: *18*.

Although he had painted landscapes in
Bologna, Annibale only fully developed this
genre in Rome, bringing to it a new, ideal
conception of nature that was basic to the
formation of classical landscape painting in
seventeenth-century Italy. In spite of his new
contribution, comparatively few landscape
paintings exist in Annibale's *œuvre*; but on the
other hand there are a large number of
landscape drawings, of which this is a fine
example. Annibale probably did not have the
making of a painting in mind when he
sketched this panorama which so successfully
represents space across an undulating plain.
The drawing has been dated *c*.1605.

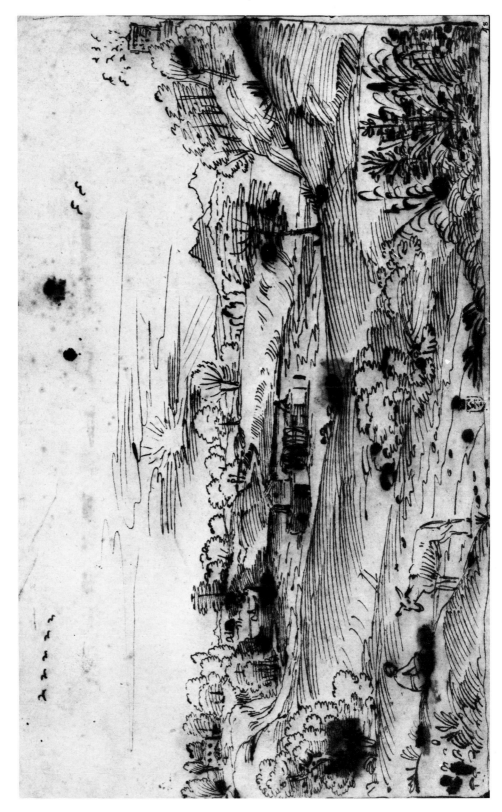

Domenico Zampieri, called
Domenichino
Bologna 1581 – Naples 1641

4 *Study for the head of St Luke*

Black chalk, heightened with white, on blue-
grey paper.

390 × 338 mm.

1920-11-16-39.

Provenance: Sir T. Lawrence (L 2445).

Literature: R. Spear, *MD*, vi, 1968, p.122.

Inscribed in pencil in the lower left-hand
corner: *S. Luca in / A. della Valle.*

 This is a preparatory study for the head of
the figure of St Luke painted on one of the
pendentives of the crossing of the church of
S. Andrea della Valle, Rome. Domenichino
completed the decoration of the pendentives in
1628. Other drawings for the St Luke
pendentive are in the Royal Library, Windsor
(see J. Pope-Hennessy, *The Drawings of
Domenichino at Windsor Castle*, London,
1948, nos.723-33).

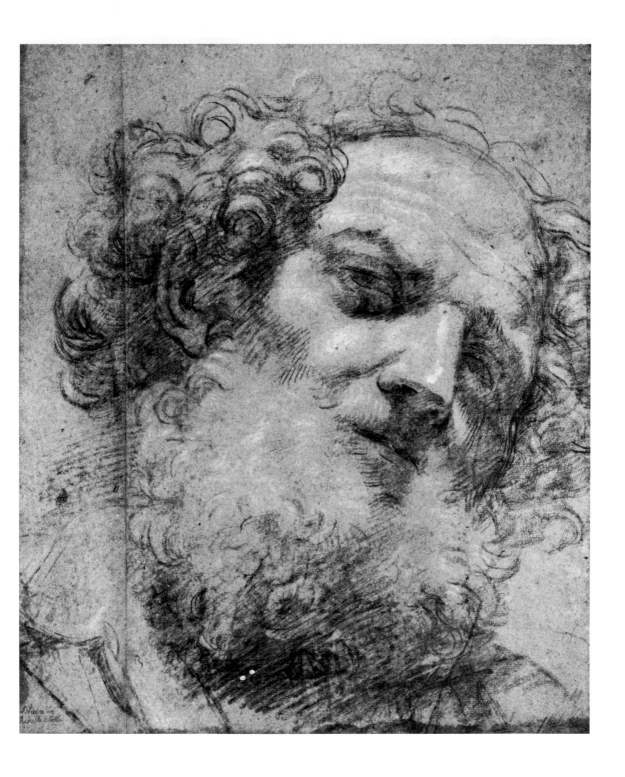

Giovanni Lanfranco
Parma 1582 – Rome 1647

5 *Scene from religious history*

Red chalk.

262 × 412 mm.

1979-10-6-88.

Provenance: Resta-Somers (inscribed in brown ink in the bottom right-hand corner: *h. 137*; as Lanfranco); ?J. Richardson, sen., on his mount, as: *C. Maratti*; unidentified collector (L2083).

The subject has not been identified, though it seems to represent either an event or a vision in the life of a female saint. Two other drawings, both with old attributions to Lanfranco, one in Christ Church, Oxford (inv. no.1162; J. Byam Shaw, *Drawings by Old Masters at Christ Church, Oxford*, Oxford, 1976, no.345, as follower of Vanni) and the other at Chatsworth (inv. no.501), are related and appear to show other incidents in the life of the same saint. Byam Shaw identified the saint in the Christ Church drawing as St Catherine of Siena, a reasonable supposition since the figure bears the marks of the stigmata. The composition of all three drawings, with the action set in open, landscape space, is not immediately suggestive of Lanfranco, though the style and handling are typical.

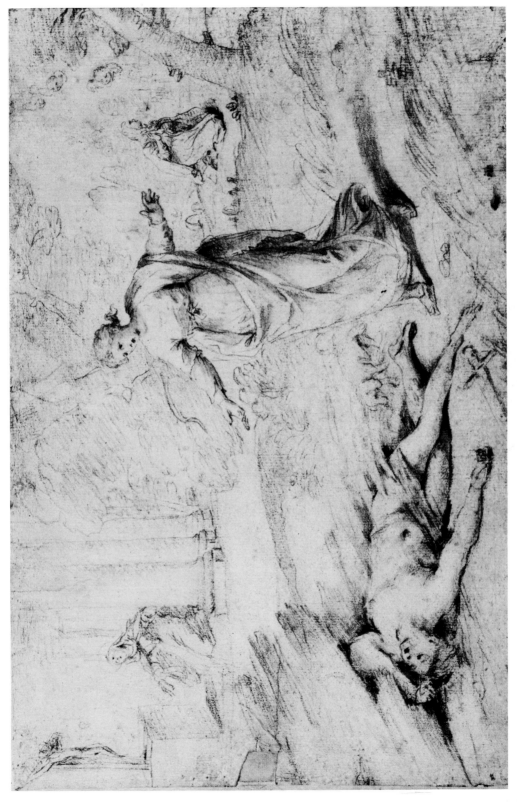

Ottavio Leoni
Rome 1587-1630

6 *Portrait of a man*

Black, red and white chalk on blue-grey paper.
222 × 159 mm.
1854-6-28-85.
Provenance: J. D. Lempereur (L 1740).

Inscribed in brown ink in the top right-hand
corner, presumably in the artist's hand: *Cava.e
Ottavio Leoni*; and in the bottom left:
299/maggio and *1624*.
 Leoni specialised as a portrait draughtsman.
His drawings are often inscribed with a
number, followed by the year and month in
which they were made. The exact purpose of
these numbers is not known, but they were
probably employed to keep a record of his
many commissions.

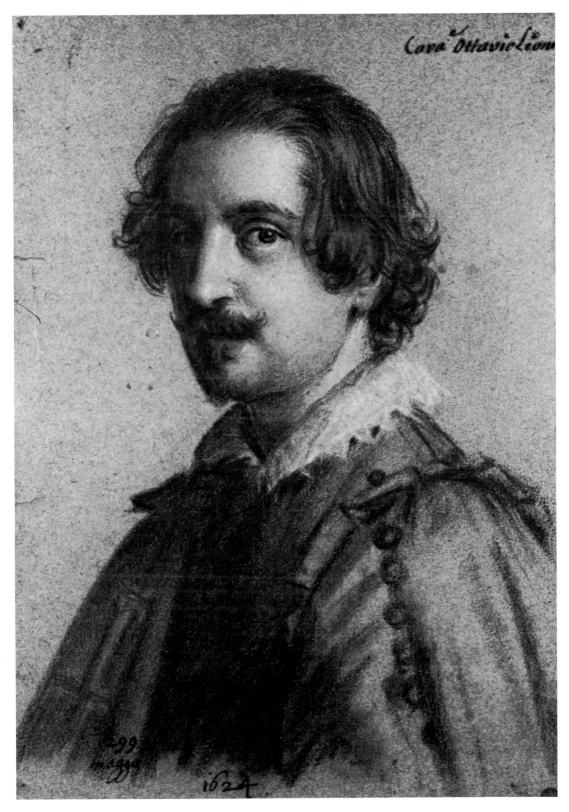

Cav° Ottavio Lioni

599
maggo
1624

Andrea Sacchi
Nettuno, near Rome 1599 – Rome 1661

7 *Man rising from the grave, surrounded by spectators*

Red chalk and light-red wash.

225 × 170 mm.

5212-22.

Provenance: W. Fawkener Bequest, 1769.

Literature: Harris and Schaar, p.37;
A. Sutherland Harris, *Andrea Sacchi*, Oxford,
1977, p.70, under no.35. Both give the
inventory number incorrectly as Ff. 3-195.

An early study for *St Anthony raising a man
from the dead*, the altarpiece painted in 1631
to 1633 for the church of S. Maria della
Concezione, Rome. In the drawing the man
raised from the dead and surrounded by a
crowd of agitated bystanders is shown to the
left of the composition instead of to the right,
as in the painting, with the crowd mostly
grouped behind the figure of the saint.

Sutherland Harris (*Sacchi*) points to the
existence of six other studies for the picture,
including another in the British Museum
(1963-11-9-25) for the whole composition.

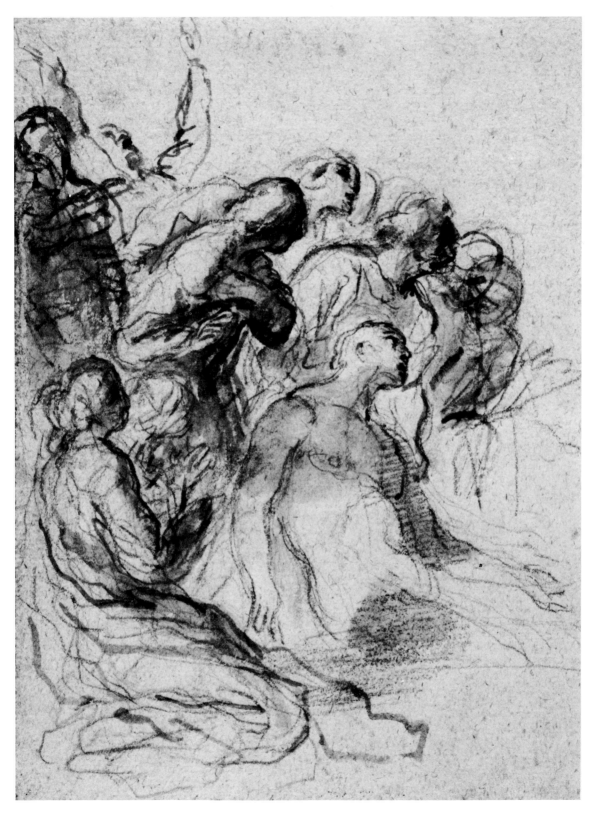

33

Andrea Sacchi

Nettuno, near Rome 1599 – Rome 1661

8 *Abigail before David*

Red chalk with light-red and brown-grey wash.
182 × 259 mm.
1975-7-26-1.
Literature: A. Sutherland Harris, *Burl. Mag.*,
CXX, 1978, p.601, n.8.

Acquired as a drawing by Sacchi's follower,
Camassei; in a letter to the Department
Sutherland Harris put forward the attribution
to Sacchi himself. No painting of the subject is
so far known.

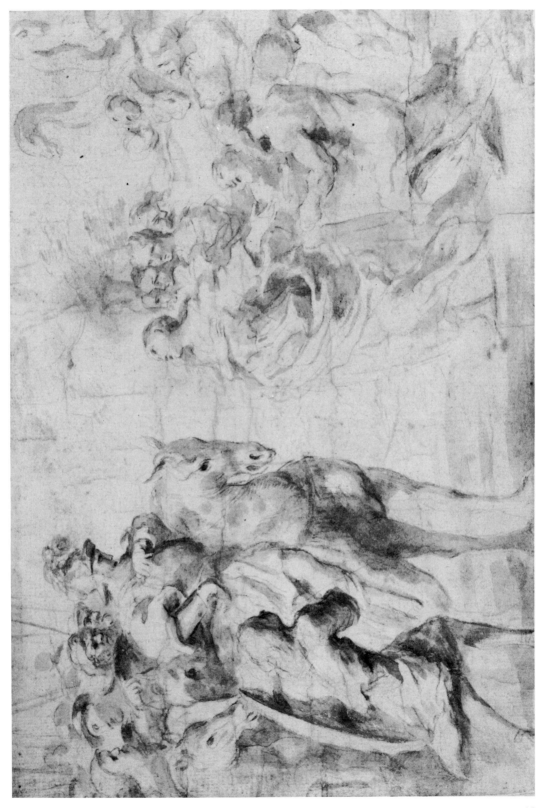

Gian Lorenzo Bernini
Naples 1598 – Rome 1680

9 *Design for the catafalque to the duc de Beaufort*

Pen and brown and grey wash.

252 × 179 mm.

1874-8-8-11.

Literature: H. Brauer and R. Wittkower, *Die Zeichnungen des Gianlorenzo Bernini*, Berlin, 1931, p.162; A. Sutherland Harris, *Selected Drawings of Gian Lorenzo Bernini*, New York, 1977, no.89.

Inscribed in brown ink in the top left-hand corner with the censor's permission for the design to be printed: *Incidat[ur]* / *P. Monardus m[agiste]r s[ocius]* / *R[everendissi]mi P[atris] M[agistri] S[acri] P[alatii] A[postolici]*.

In 1669 François de Vendôme, duc de Beaufort, was ordered by Louis XIV to bring a division of the French fleet to the aid of the Venetians, then besieged by the Turks at Candia. The combined French and Venetian fleets were defeated, Beaufort killed, and the island taken; but in gratitude to the French king for his aid in the war Pope Clement IX commissioned Bernini to design a catafalque for the duke's obsequies in the church of S. Maria d'Aracoeli, Rome. An engraving of the catafalque by Pietro Santi Bartoli from the published account of these obsequies (Brauer and Wittkower, pl.193b) shows several minor changes of design, indicating that the present drawing is an early study for the project.

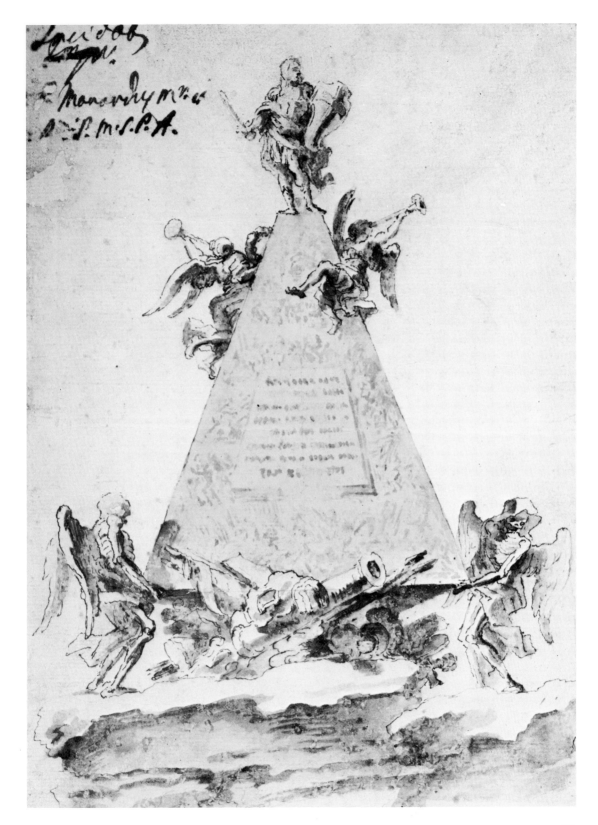

Gian Lorenzo Bernini
Naples 1598 – Rome 1680

10 *Self-portrait as an old man*

Black and yellowish-white chalk on buff paper.
360 × 241 mm.
1890-10-13-5.
Literature: *Portrait Drawings* (exh. cat., British Museum), London, 1974, no.135.

Drawn in Bernini's last years. The artist is here shown to be older than he appears in the self-portrait at Windsor, executed in *c*.1665 (Blunt and Cooke, no.54).

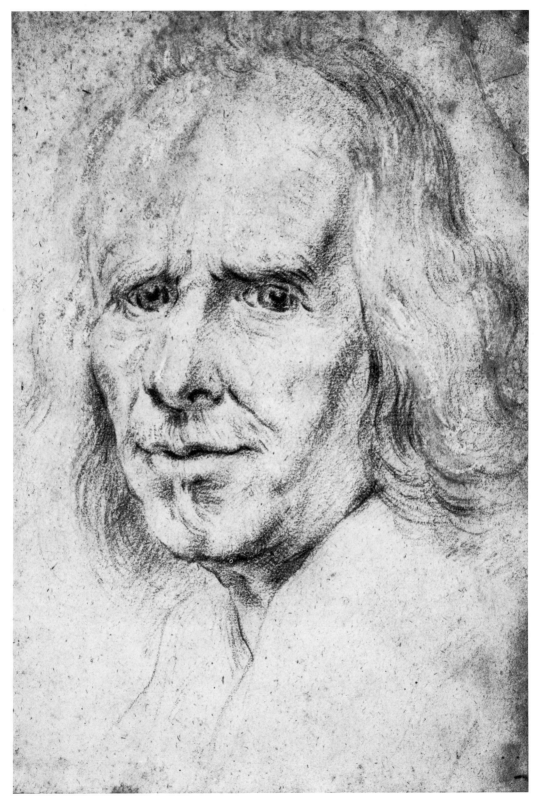

Alessandro Algardi
Bologna 1602-1654

11 *Hercules shooting at the Stymphalian Birds*

Pen and brown ink over black chalk.
252 × 190 mm.
1946-7-13-1383.
Provenance: ?Sir T. Lawrence;
Phillipps-Fenwick; presented anonymously.
Literature: Popham, *Fenwick*, p.126, no.3, as
Bernini; W. Vitzthum, *Bollettino d'Arte*, xlviii,
1963, p.88.

Inscribed in the bottom centre in brown ink:
Bernini; and, above, very faintly in black
chalk: *l'algardi*; numbered to the right in
brown ink: *N. 36*.
 A study for one of the stucco reliefs
(reproduced in O. Raggio, *Paragone*, xxii,
1971, no.251, pl.16b) executed in 1646 for the
ceiling of the Galleria di Ercole, Villa Pamphili,
Rome. The shooting of the Stymphalian Birds
was the sixth of the Twelve Labours of
Hercules.

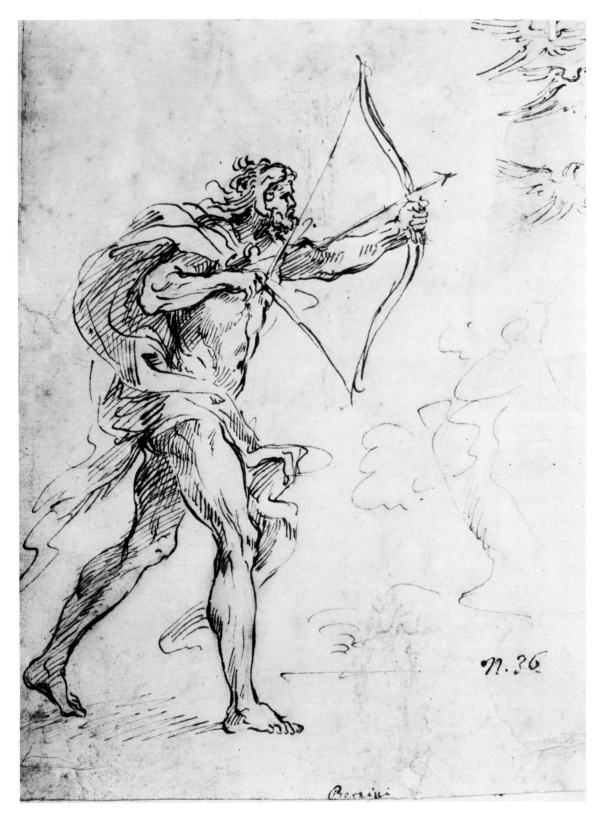

n.36

Bernini

Giovanni Angelo Canini
Rome 1617-1666

12 *Life class in an academy*

Red chalk.
309 × 240 mm; lower edge damaged.
1946-7-13-708.
Provenance: Sir T. Lawrence (L 2445);
Phillipps-Fenwick; presented anonymously.
Literature: Popham, *Fenwick*, p.131, no.1;
Vitzthum, fig.22.

Inscribed along the bottom in brown ink:
di Gio Angiolo Canini scolaro del Domenichino.
 This shows what must have been the typical
appearance of a seventeenth-century studio
arranged for a life class. Students are seated in
front of the model who is raised above them
on what appears to be a trestle table; he
sustains his pose by holding a staff; a lamp
hanging above provides a single source of
illumination, emphasising the forms of the
model's anatomy.
 As the inscription indicates, Canini was a
pupil of Domenichino. According to his
biographer, Giovanni Battista Passeri, he was
more successful as a draughtsman than as a
painter.

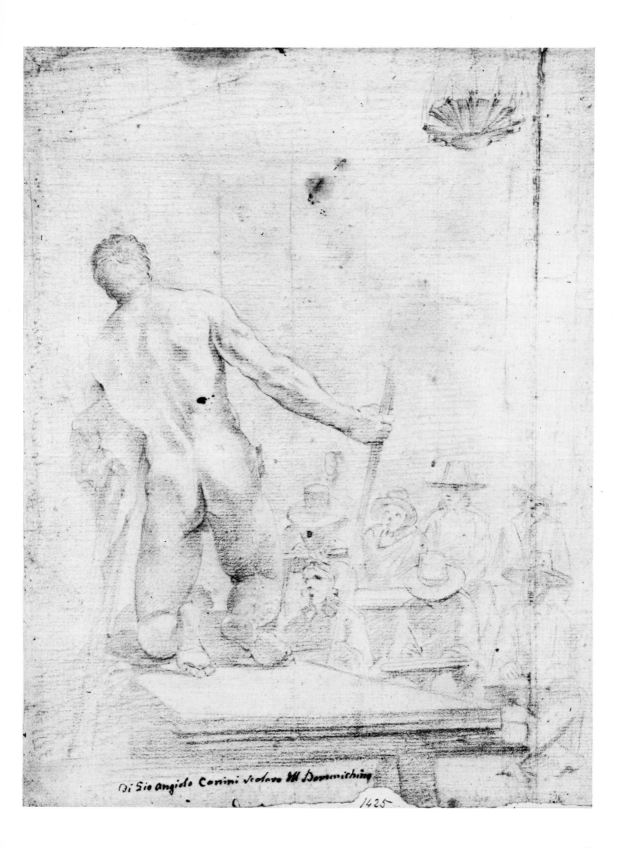

Di Sio angiolo Canini scolaro del Domenichino

1425

Pietro Berrettini, called Pietro da
Cortona
Cortona 1596 – Rome 1669

13 *Half-length figure of a woman carrying
the fasces on her shoulder*

Black chalk, heightened with white, on grey
paper.

250 × 282 mm.

5211-23.

Provenance: W. Fawkener Bequest, 1769.

Literature: G. Briganti, *Pietro da Cortona*,
Florence, 1962, p.306.

One of the few surviving studies for Cortona's
early masterpiece, the *Allegory of Divine
Providence*, painted between 1631 and 1639
on the ceiling of the great hall of the Palazzo
Barberini in Rome. The figure occurs in the
centre of the upper part of the scene of the
Labours of Hercules. A finished study for the
head and shoulders, with only minor
differences from the painted solution, is in the
Nationalmuseum, Stockholm (inv. no.1863/601).

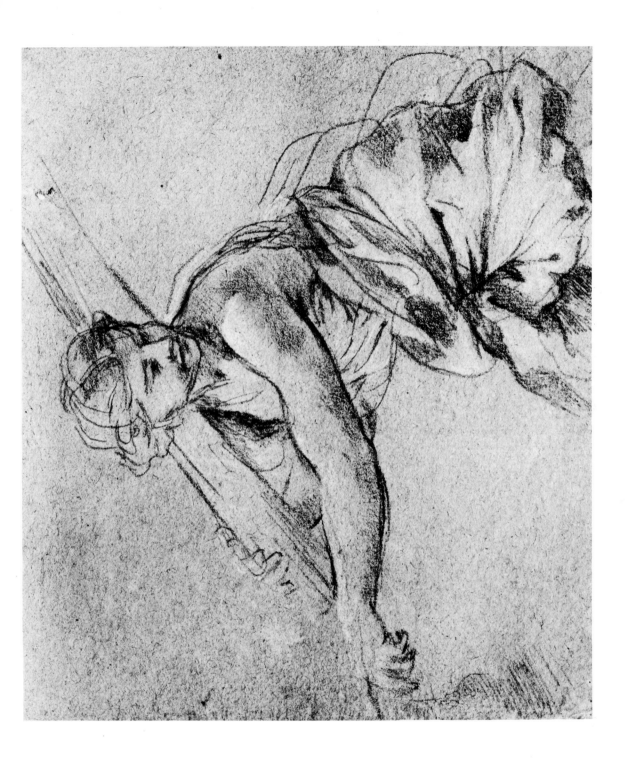

Pietro Berrettini, called Pietro da Cortona

Cortona 1596 – Rome 1669

14 *Return of Hagar*

Pen and brown ink.
166 × 154 mm; lower right-hand corner made up.
Ff. 3-188.
Provenance: W. Fawkener Bequest, 1769.
Literature: *Dessins Romains du XVIIe Siècle*
(exh. cat., Cabinet des Dessins, Musée du
Louvre), Paris, 1959, under no.25.

A more finished study, in black chalk in reverse
and with several variations, is in the Louvre
(inv. no.474). The composition resembles that
of two paintings of the same subject, one in the
Rumjantzeff-Museum, Moscow (reproduced
in H. Voss, *Die Malerei des Barock in Rom*,
Berlin, 1924, p.261), and the other in the
Kunsthistoriches Museum, Vienna (reproduced
in Voss, also p.261); both can be dated *c*.1640.
Of the two the drawing resembles most closely
that in Vienna, but in reverse.

A study for the figure of Hagar alone has
recently entered the collection (1977-11-5-13). It
was presumably intended to be pasted down
over the much corrected, corresponding figure
of the present sheet, the scale of the figure in
both drawings being almost the same; it is
drawn in the same coloured ink, and there are
lines drawn to key it with the design of the
surrounding composition.

The existence of a pendant to no.14,
representing the *Expulsion of Hagar*, and also
in the British Museum (Ff. 3-189), suggests that
Cortona at one stage was planning to paint the
Expulsion and *Return of Hagar* as a pair.

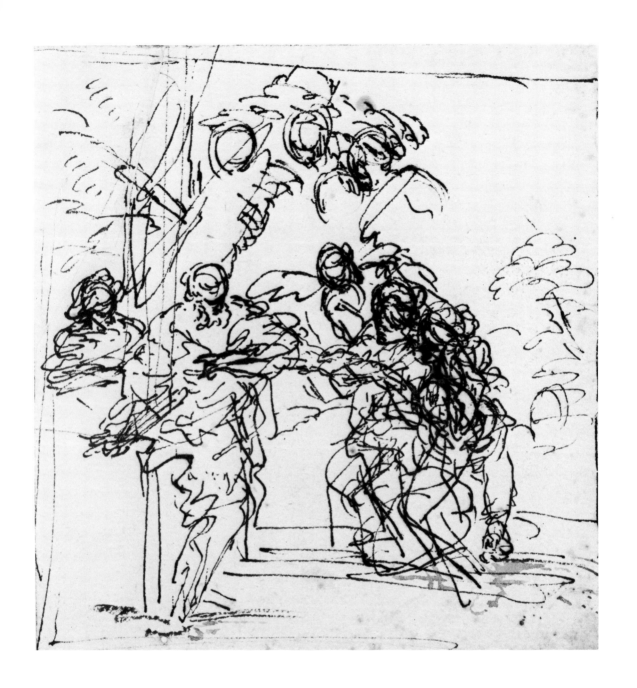

Pietro Berrettini, called Pietro da
Cortona
Cortona 1596–Rome 1669

15 *Martyrdom of St Martina*

Brush drawing in grey wash, heightened with
white, over black chalk on buff paper; squared
in black chalk.

296 × 189 mm.

1959-5-9-1.

Literature: W. Vitzthum, *Revue de l'Art*, vi,
1969, p.99.

A preparatory study for the altarpiece, painted
soon after 1655, formerly in the church of S.
Francesco and now in the Pinacoteca in Siena
(reproduced in G. Briganti, *Pietro da Cortona*,
Florence, 1962, pl.268).

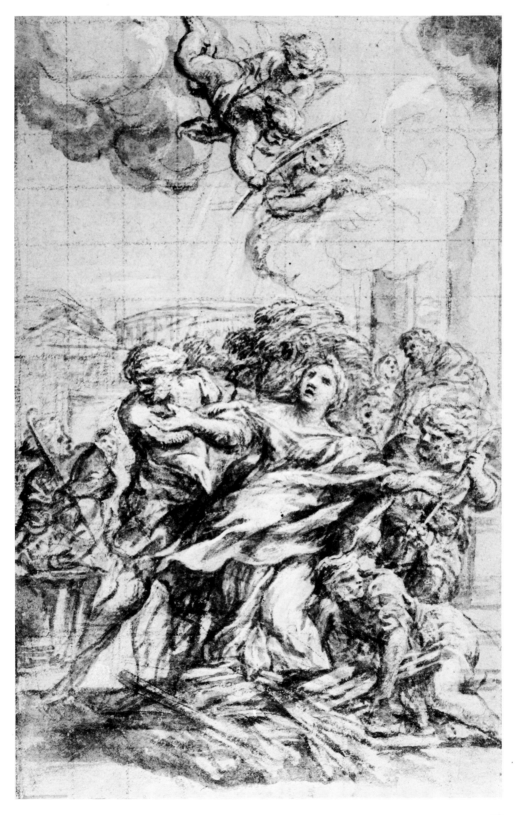

49

Pietro Testa
Lucca 1612 – Rome 1650

16 *Allegory of Painting*

Pen and brown ink over black chalk;
overdrawn in parts with red chalk.

266 × 344 mm.

Pp. 5-95.

Provenance: Marquis de La Mure; Payne
Knight Bequest, 1824.

Literature: A. Sutherland Harris, *Paragone*,
xviii, 1967, no.213, p.52, n.30.

A study in reverse for one of Testa's early
etchings (B XX, p.223, no.29). Superimposed
on the pen-and-ink drawing is an irregular
pattern in red chalk, corresponding with the
division of work to be done on the plate. With
the same chalk, the artist has made two
corrections to the design itself: the addition of
a branch to the tree to the left and the
lowering of the position of the putto at the
foot of the altar. These changes were
incorporated in the finished print.

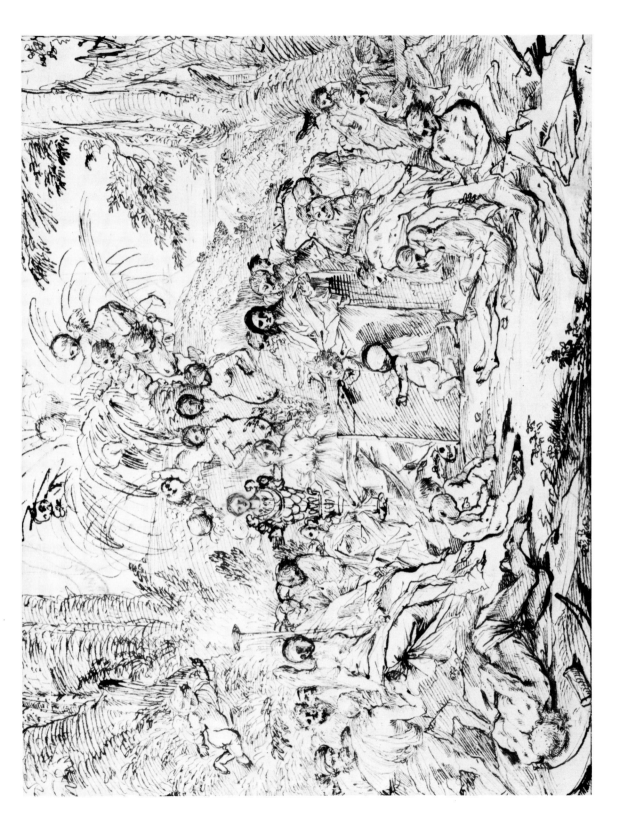

Pietro Testa
Lucca 1612 – Rome 1650

17 *Study for the central foreground group in the* Liceo della Pittura

Pen and brown ink with black chalk.
189 × 259 mm.
1874-8-8-143.
Literature: A. Sutherland Harris, *Paragone*, xviii, 1967, no.213, p.52, n.30.

Extensively inscribed in brown ink and black chalk, partly in Testa's hand. In the bottom left-hand corner is an old attribution in brown ink: *Pietro Testa*; in the top right-hand corner, the number *114*.

The group here shown appears in reverse in the centre foreground of the *Liceo della Pittura* (B XX, p.226, no.34), Testa's most famous etching which he made in *c.*1640.

As can be deduced from the inscriptions on the drawing, the action of the figures symbolises three successive phases in the education of an artist: the first, represented by the boy and the two putti on the lower step, is the study of the work of the masters (*'da Arte, primo'*); the second, represented by the two boys above leaning over a drawing-board and moving away from the figures on the lower step, is the study of nature (*'da natura, secondo'*); the third, represented by two young men following the pointing hand of the man with the winged head, is the pursuit of intellectual knowledge (*'da ragione terzo'*). This progression is also illustrated by the upward movements of the figures and by their respective ages, from the infancy of the children seated below to the young manhood of the two figures at the top of the steps. An alternative position for the left arm of the boy immediately below the man with the winged head is indicated in black chalk. He is shown clutching a statuette of Ephesian Diana. But this change was not adopted in the final design.

En suite with the British Museum drawing are two drawings in the Uffizi, Florence (inv. nos.774F and 775F), respectively studies in reverse for the left and right figure groups in the foreground of the print. Other studies are in the Kunstmuseum, Düsseldorf (E. Cropper, *Journal of the Warburg and Courtauld Institutes*, xxxiv, 1971, pp.267ff., pls.42a and b).

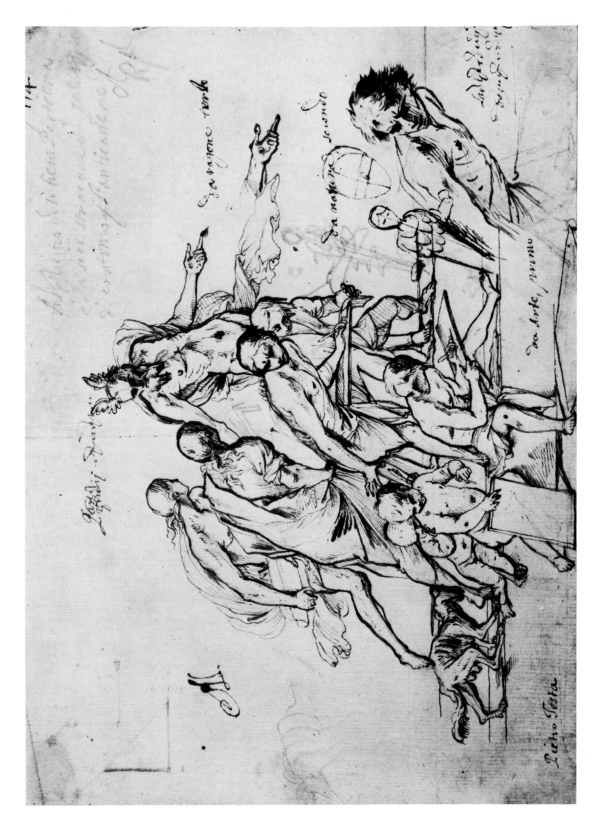

53

Pier Francesco Mola
Coldrerio 1612 – Rome 1666

18 *Studies for a composition of the dream of St Joseph*

395 × 265 mm.

1946-7-13-720.

Provenance: Phillipps-Fenwick; presented anonymously.

Literature: Popham, *Fenwick*, p.49, no.3 (as Ludovico Carracci); Harris and Schaar, p.55.

Inscribed in brown ink in the bottom left-hand corner: *Ludovico Caratti 12*: (the number *12* is cancelled); and in the bottom right-hand corner: *2 Shill.*

In this drawing Mola seems to have been inspired by Sacchi's fresco of the *Dream of St Joseph*, painted in *c*.1652 in the church of S. Giuseppe a Capo le Case, Rome.

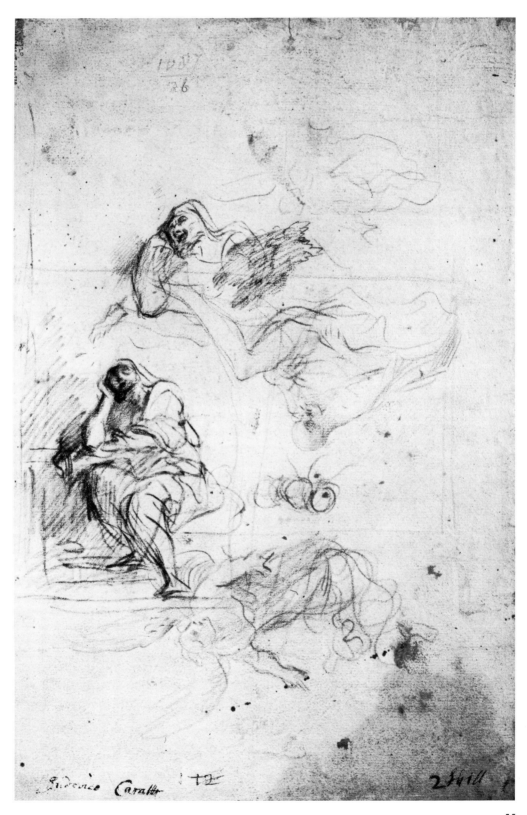

Pier Francesco Mola
Coldrerio 1612 – Rome 1666

19 *Joseph greeting his brethren; study of three of the brethren*

Brush drawing in brown wash over red chalk, with additions in pen and brown ink and black chalk.

324 × 443 mm.

1853-10-8-10.

Literature: A. Sutherland Harris, *Revue de l'Art*, vi, 1969, pp.82f.; R. Cocke, *Pier Francesco Mola*, Oxford, 1972, p.58, under no.49.

For the fresco completed in 1657 in the Gallery of Alexander VII in the Quirinale Palace, Rome. The preparation of the design caused Mola some difficulty, judging from the large number of surviving studies many of which show quite different solutions from the final composition. This is perhaps the finest of the group.

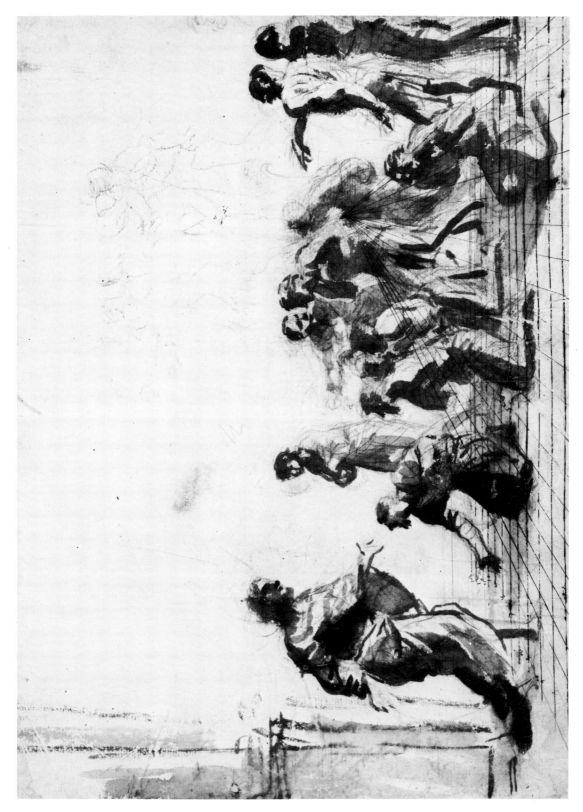

Pier Francesco Mola
Coldrerio 1612 – Rome 1666

20 *The Expulsion*

Pen and brown wash.
251 × 198 mm.
1946-7-13-88.
Provenance: Resta-Somers (inscribed in brown
ink in the bottom right-hand corner: *n.14*);
Phillipps-Fenwick; presented anonymously.
Literature: Popham, *Fenwick*, p.153, no.1.

A typical example of Mola's rapid and
pictorial style of drawing.

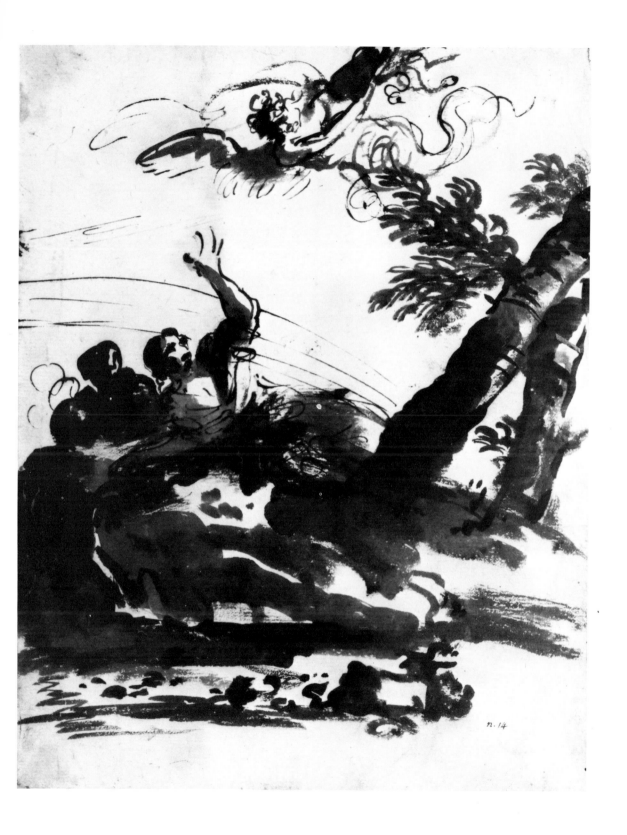

n. 14

Giovanni Francesco Romanelli
Viterbo *c.*1610-1662

21 *Hero of antiquity and a woman among farmhands*

Pen and brown ink with pale-blue wash; squared in black chalk.

277 × 338 mm.

Ff. 3-196.

Provenance: R. Houlditch (L 2214 followed by the number 2); J. Barnard (L 1419); Rev. C. M. Cracherode Bequest, 1799.

Literature: B. Kerber, *Giessener Beiträge zur Kunstgeschichte*, ii, 1973, p.143.

The subject of this fine drawing has not so far been identified. Romanelli's style of drawing is based largely on that of Cortona in the mid-to-late 1630s.

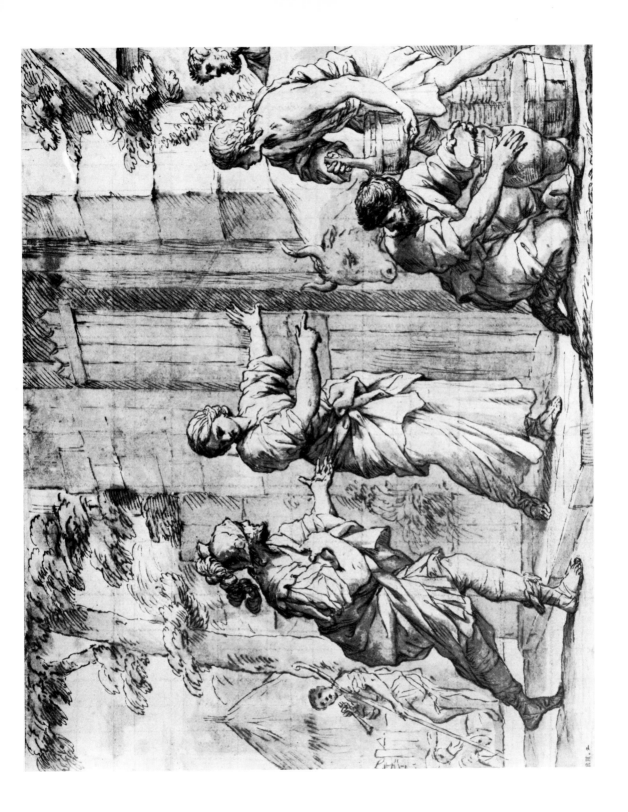

Giacinto Gimignani

Pistoia 1611 – Rome 1681

22 *Triumph of David*

Pen and brown wash, heightened with white,
on light-brown paper.

270 × 623 mm.

1979-4-7-2.

A study for the painting of *c.*1640 in the
Museum of Israel, Jerusalem (reproduced in
U. V. Fischer-Pace, *La Revue du Louvre*,
nos.5-6, 1978, p.345).

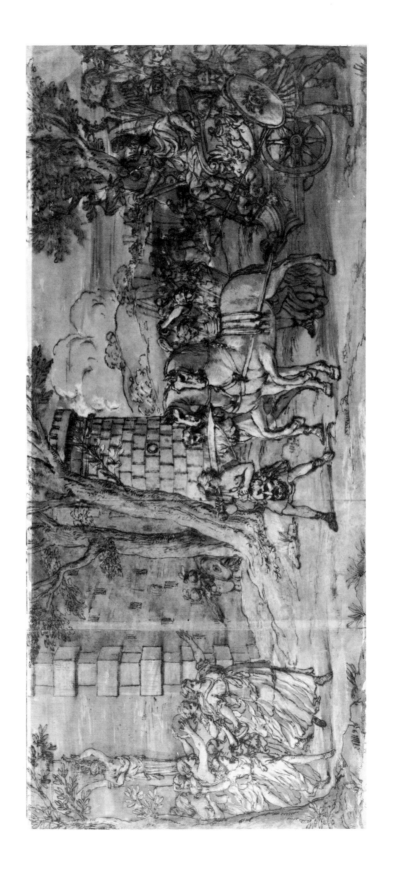

63

Giovanni Bonatti

Ferrara 1635 – Rome 1681

23 *Half-length study of an acolyte holding
a book in his right hand and pointing to
it with his left*

Black chalk, heightened with white, on buff
paper.

256 × 202 mm.

5212-47.

Provenance: J. Richardson, sen. (L 2184);
W. Fawkener Bequest, 1769.

Inscribed in brown ink in Richardson's hand
on the back of the old mount: *Studio per una
figura del quadro che està nella Capella Spada
in Chiesa nuova / in Roma, rappresentante S.
Carlo Borromei, che libera Milano dalla
peste. / Giovanni Bonati del:-1665.*

As the inscription by Richardson indicates,
this is a study for the painting of *St Charles
Borromeo succouring the Plague-Stricken* in the
Spada Chapel of the Chiesa Nuova (S. Maria
in Vallicella), Rome (reproduced in
E. Riccòmini, *Il Seicento Ferrarese*, Milan,
1969, pl. 51b). Though the pose of the acolyte
in the painting is identical with that in the
drawing, in the former he is represented as an
older man. A study for the figure of the saint is
in the Capodimonte in Naples (vol. I. B, 66),
and a study for the woman supporting in her
lap a sick youth, in the lower left of the
painting, is in the Kunstmuseum, Düsseldorf
(FP 1617).

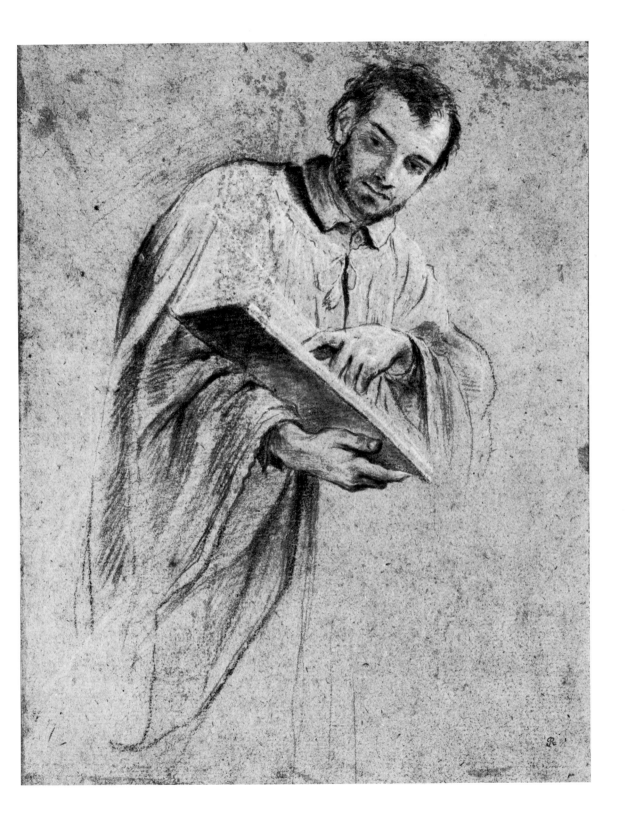

Ciro Ferri

Rome 1634-1689

24 *Male nude seated on the ground*

Black chalk, heightened with white, on buff
paper.

292 × 396 mm.

1946-7-13-81.

Provenance: Sir T. Lawrence (L 2445);
Phillipps-Fenwick; presented anonymously.

Literature: Popham, *Fenwick*, p.137, no.4 (as
Pietro da Cortona).

Inscribed in red chalk in the lower left-hand
corner: *P. Cortona*; and in the lower right-
hand corner: *No.2*.

Previously attributed to Cortona, Walter
Vitzthum in a note on the mount restored it to
Ferri. It is in fact typical of Ferri's finished
chalk drawings of which another example is in
the Ratjen Collection, Vaduz (*Stiftung Ratjen:
Italienische Zeichnungen des 16-18
Jahrhunderts*, exh. cat., Munich, 1977, no.87).

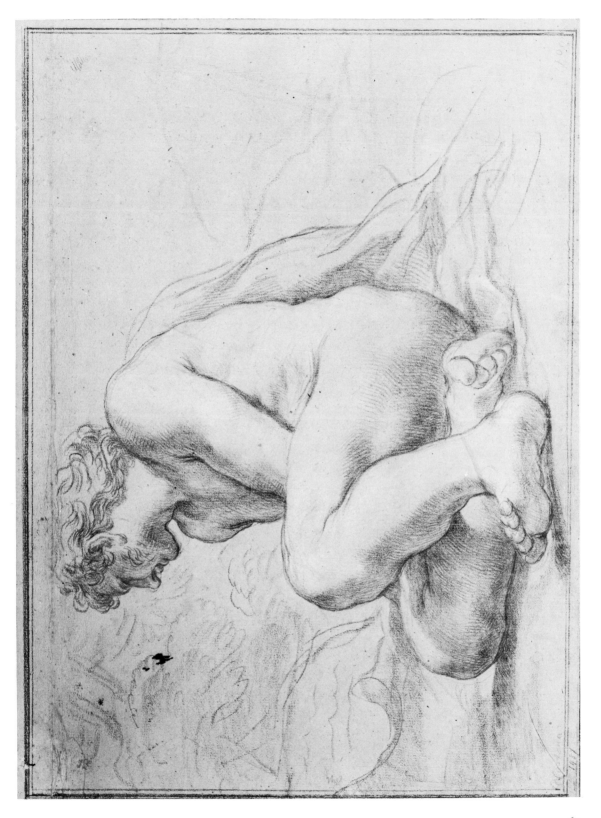

67

Ciro Ferri
Rome 1634-1689

25 *Christ on the Cross adored by the Virgin Mary, St Mary Magdalene and St John*

Pen and brown and grey wash, heightened with white, over black chalk; the outlines indented for transfer.

319 × 187 mm.

1895-9-15-665.

Provenance: E. Bouverie (L 325); J. Malcolm.

Literature: G. Briganti, *Pietro da Cortona*, Florence, 1962, p.305 (as Pietro da Cortona); N. Turner, *Prospettiva*, 17, April 1979, p.77.

This drawing, previously attributed to Pietro da Cortona, is a final study in reverse by Ciro Ferri for the print engraved by Cornelis Bloemaert (F. Hollstein, *Dutch and Flemish Etchings, Engravings and Woodcuts*, Amsterdam, 1949-, vol.II, p.72, no.33) and included as one of the illustrations to the *Messale di Alessandro VII* of 1662, a well-known contemporary revision of the Latin rites according to the Tridentine reform.

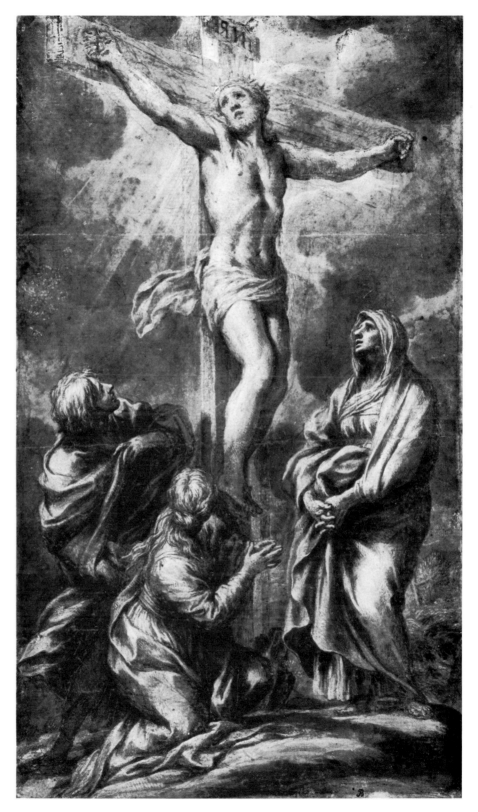

Lazzaro Baldi

Pistoia 1624–Rome 1703

26 *St Luke*

Pen and brown wash over black chalk, heightened with white, on buff paper; the outlines indented.

374 × 251 mm; laid down on a backing decorated with an elaborate ornamental surround.

1941-10-11-71.

Provenance: inscribed in pencil on the backing: *From the Fountain Collection.*

Literature: N. Turner, *Burl. Mag.*, cxxi, 1979, pp.153f.

A. E. Popham in a note on the mount was the first to observe that this drawing is the preparatory design for Pietro Aquila's etching entitled *Accademia del Disegno* (C. Heinecken, *Dictionnaire des Artistes dont nous avons des Estampes*, vol.i, Leipzig, 1778, p.426). The print celebrates the Accademia di S. Luca, the Academy of painters, sculptors and architects in Rome, and was almost certainly made to illustrate a discourse delivered by the Secretary of the Academy, Giuseppe Ghezzi, on 15 November 1679 at the annual prize-giving. The subject of the discourse was the explanation of the emblem of the sun illuminating three fruit-bearing trees (Painting, Sculpture and Architecture) which appears in the cartouche immediately below the figure of the Evangelist. Baldi was President in 1679, the only year in which he held this office.

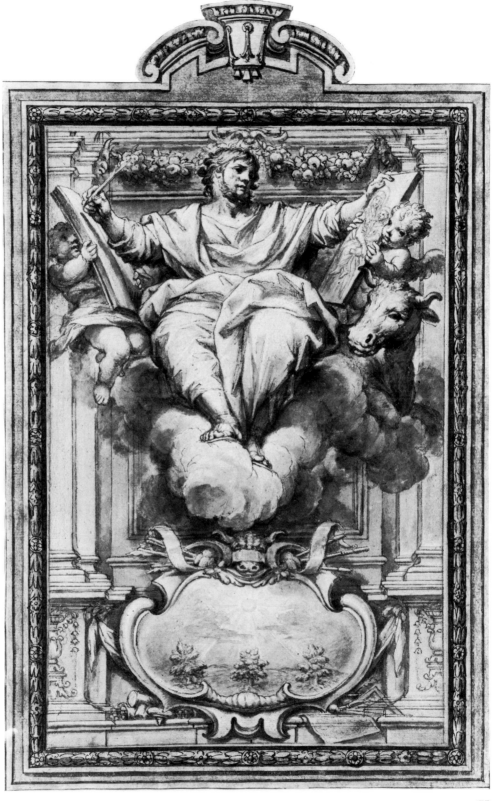

71

Guglielmo Cortese (and assistant)
St Hippolyte, France 1628 – Rome 1679

27 *Mystic Marriage of St Catherine*

Pen and brown wash over red chalk.
375 × 214 mm.
1950-11-11-35.
Provenance: R. von Audenaerd; R. Hilditch.

From an album that once contained mostly
drawings by Luca Giordano and Domenico
Piola, to whom this drawing was formerly
attributed.

At first sight this has the appearance of a
copy; however, the red chalk underdrawing
and the correction to the leg of the putto at the
bottom of the angel group at the top left reveal
typical traits of the artist's hand. The drawing
is related to the composition of a lost painting
known from three studies in the Kunstmuseum,
Düsseldorf (Graf, 1976, nos.137-9). It has been
suggested that this was the painting sold from
the Ottoboni Collection in 1740. The British
Museum drawing is of particular importance as
it records the complete composition.

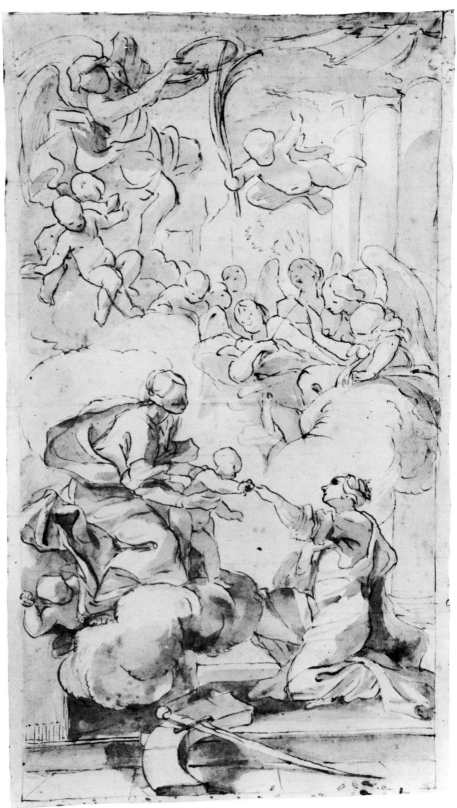

Carlo Maratta

Camerano 1625 – Rome 1723

28 *Adoration of the shepherds*

Black chalk and brown wash, heightened with white.

169 × 304 mm; semicircular.

1973-9-15-5.

Literature: K. Roberts, *Burl. Mag.*, cxviii, 1976, p.175.

A study, corresponding closely but not exactly to the finished painting, for a lunette-shaped fresco in the first chapel on the right in the church of S. Isidoro, Rome, the decoration of which, commissioned in 1652, was one of Maratta's earliest Roman works. Besides showing the influence of his master, Andrea Sacchi, the drawing also reveals his dependence on Pietro da Cortona's more experimental style of drawing.

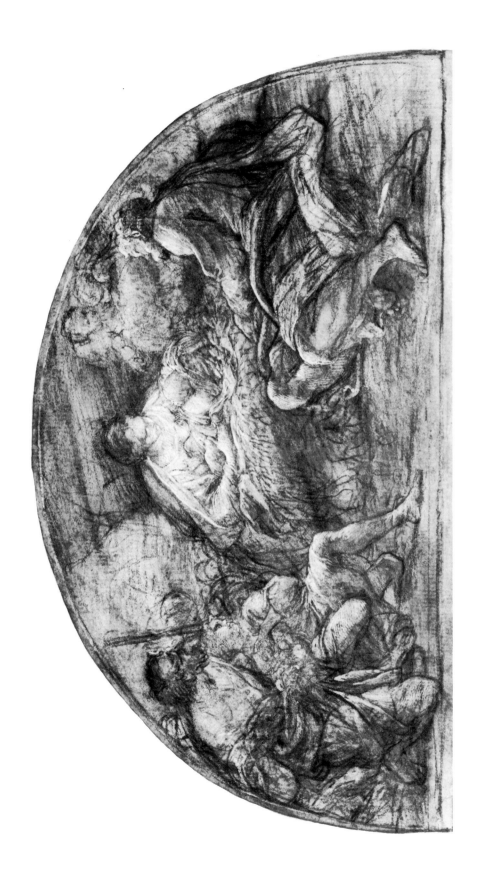

Carlo Maratta
Camerano 1625 – Rome 1723

29 *Study for a figure of St John the Evangelist; two studies of his right hand*

Red chalk, heightened with white, on blue paper.
394 × 257 mm.
1938-6-11-7.
Provenance: Sir J. Reynolds (L 2364); J. Malcolm.
Literature: Harris and Schaar, p.127.

For the figure of St John the Evangelist who appears standing to the left in *St John the Evangelist disputing the subject of the Immaculate Conception of the Virgin with the Church Fathers, Sts Gregory, John Chrysostom and Augustine*, the altarpiece painted in 1686 for the Cappella Cybo in S. Maria del Popolo, Rome. The pose corresponds almost exactly to that of the painting.

Other studies for the figure are in the Kupferstichkabinett, Berlin; the Kunstmuseum, Düsseldorf; and the Uffizi, Florence. (See Harris and Schaar.)

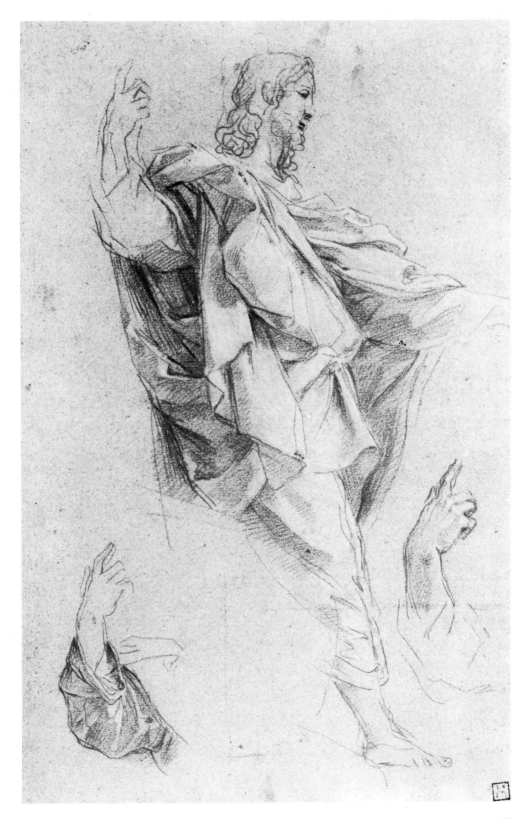

Carlo Maratta

Camerano 1625 – Rome 1723

30 *Noli me tangere*

Pen and brown wash over red chalk.
182 × 252 mm.
1950-2-11-12.
Literature: Harris and Schaar, p.175.

Inscribed in brown ink in the bottom centre of the sheet: *S.r Carlo Maratti.*
 Another drawing for the same composition, for which no painting has yet been found, is in the Kunstmuseum, Düsseldorf (Harris and Schaar, no.598).

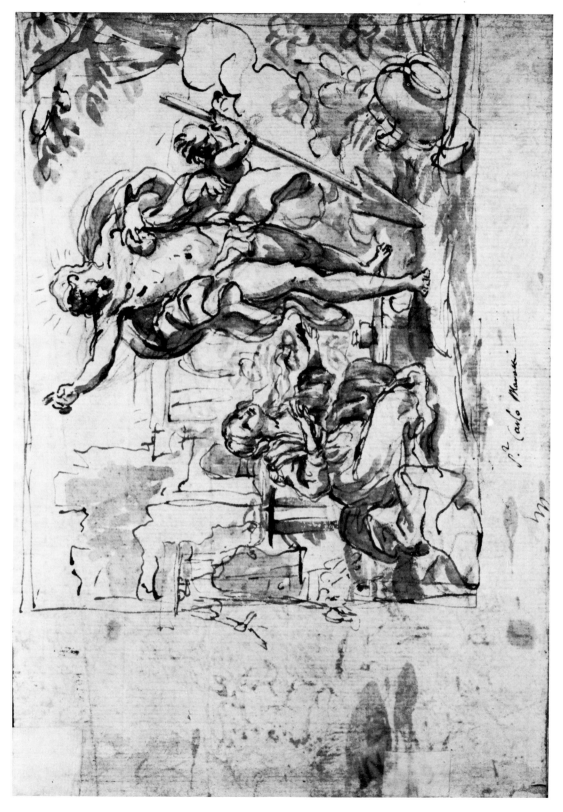

Carlo Maratta
Camerano 1625 – Rome 1723

31 *Caricature of the Pope (?Clement IX) and six Cardinals*

Red chalk.

190 × 355 mm.

1956-5-12-3.

Provenance: J. Richardson, sen. (L 2184; on his mount).

Literature: Hogarth (exh. cat., British Museum), London, 1964-5, no.76.

Inscribed in brown ink on the back of an old mount in Richardson's hand: *G.15.4.2. Carlo had a Mistress which some of the Jesuit Cardinals persuaded the Pope to cause to be driven from him; in Revenge he caricatura'd 'em all. This is it.* The Pope here shown is possibly Clement IX (Rospigliosi), 1667-9.

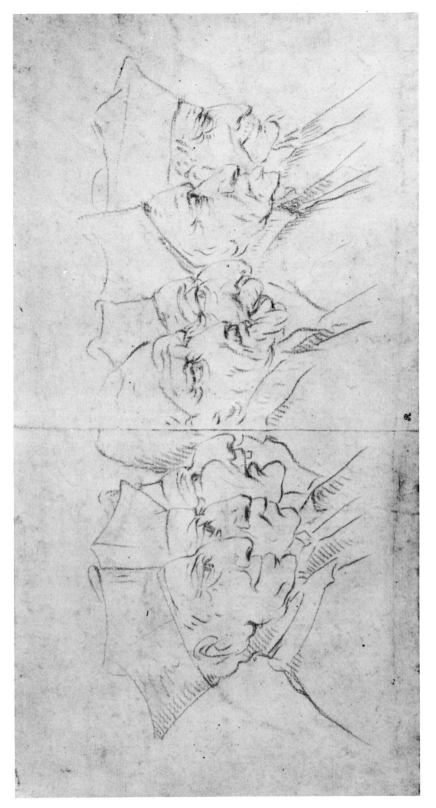

Giuseppe Passeri
Rome 1654-1714

32 *Triumphal procession*

Pen and brown ink over red chalk, heightened
with white, on paper washed light red; squared
in red chalk.

373 × 267 mm.

1902-8-22-10.

This is characteristic of Passeri and reveals the
strong influence of his master, Carlo Maratta.
The technique of broken pen-and-ink lines over
chalk underdrawing, reinforced by red wash
and white heightening, was often used in his
composition drawings.

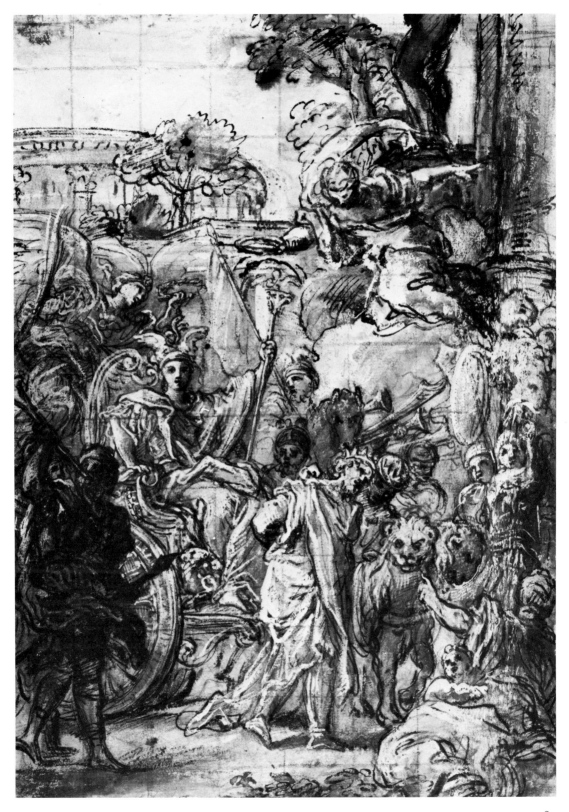

83

Johann Paul Schor
Innsbruck 1615 – Rome 1674

33 *Miracle of St Thomas of Villanueva*

Brush drawing in grey, heightened with white, over black chalk.

190 × 189 mm.

1952-1-21-15.

This and a second drawing in the British Museum (1951-1-21-7) representing another miracle of the saint, both formerly attributed to Giovanni Battista Lenardi, are designs for two of the medallions in a series used as part of the temporary decoration erected in St Peter's, Rome, on the occasion of the canonisation in 1653 of the Spanish saint, Thomas of Villanueva. Two designs by Schor for the whole decoration – a section of the nave and a section of the dome and transept of St Peter's – are at Windsor (Blunt and Cooke, nos.943 and 944) and show that the medallions hung below the arches of the nave and transepts of the basilica. The medallions were engraved in reverse by G. G. de Rossi (the series is reproduced in M. Fagiolo dell'Arco and S. Carandini, *L'Effimero Barocco*, Rome, 1977, pp.178-9).

Schor's designs were repeated immediately afterwards in the marble medallions by Antonio Raggi of 1658-61 at the base of the dome of S. Tommaso da Villanova at Castelgandolfo, outside Rome. The British Museum drawings are in the same sense as the two corresponding medallions by Raggi.

Though Austrian in origin, Schor's career was spent almost entirely in Rome where he worked in Bernini's studio, specialising in the design of decorative rather than figurative sculpture.

Giovanni Battista Gaulli, called Baciccio

Genoa 1639–Rome 1709

34 *Holy Family in a landscape*

Pen and brown ink with grey wash over black
chalk; squared in black chalk.
311 × 238 mm.
1895-9-15-669.
Provenance: J. Malcolm.
Literature: Graf, 1976, p.143.

Inscribed in brown ink in the lower left-hand
corner: *Baciccia.*

From its style, the drawing may be dated to
the 1680s. The fact that it is squared suggests
that it is a study for a painting, though no such
painting survives. A study for the figure of the
Child Christ is in the Kunstmuseum,
Düsseldorf (Graf, no.446).

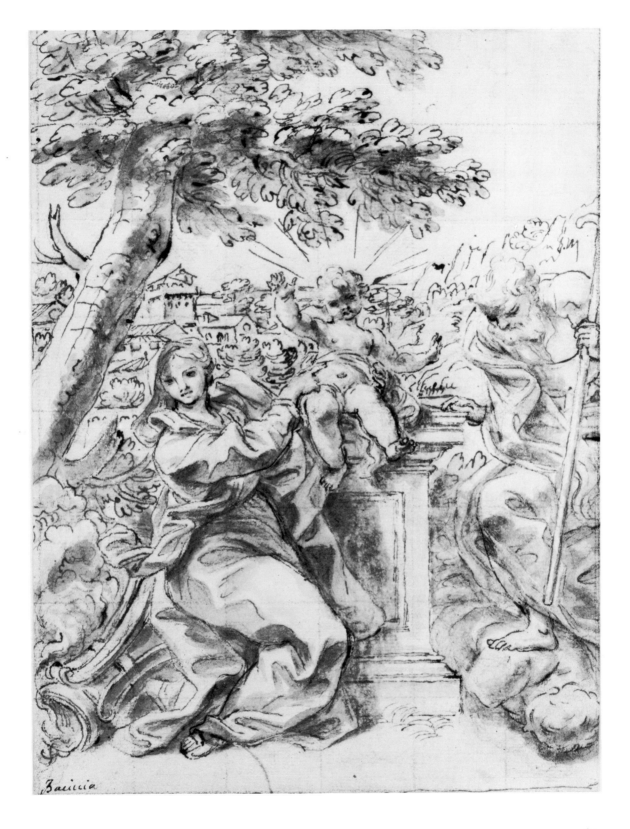

Baciccia

Bolognese Drawings

Annibale Carracci
Bologna 1560 – Rome 1609

35 *Boy angel playing a violin*

Red chalk.

165 × 202 mm.

1895-9-15-723.

Provenance: Sir T. Lawrence (L 2445); J. Malcolm.

Literature: A. E. Popham, *Correggio's Drawings*, London, 1957, p.182, no.A56 (as Annibale Carracci); D. Posner, *Annibale Carracci*, vol.II, London, 1971, p.11, under no.21.

A study for the angel in the upper right of the altarpiece, in the church of S. Gregorio, Bologna, of the *Baptism of Christ*, dated 1685, one of Annibale's first public commissions. The strong influence of Correggio on the painter's early drawing style is apparent.

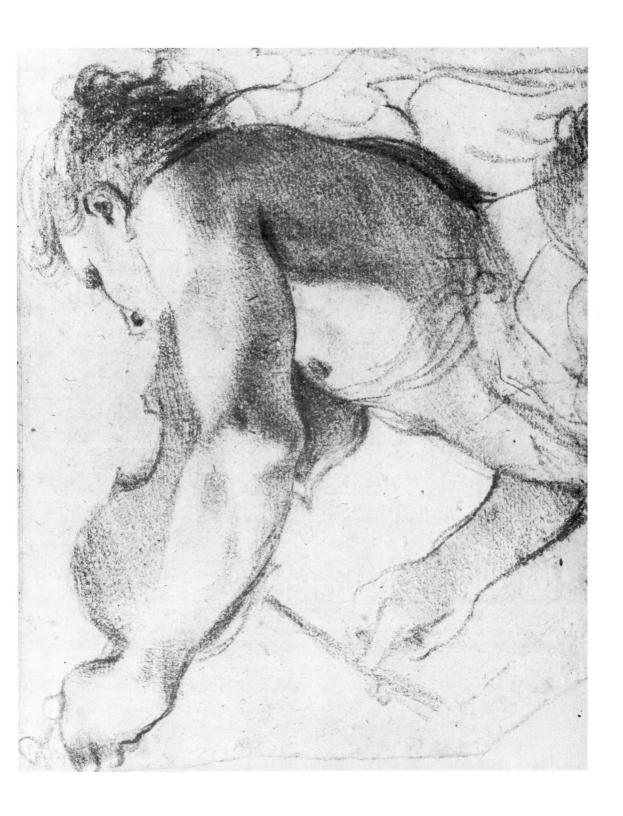

Agostino Carracci
Bologna 1557 – Parma 1602

36 *Landscape with figures by a river; pair*
of clasped hands; head of a boy

Pen and brown ink.

173 × 211 mm.

1895-9-15-696.

Provenance: P. J. Mariette (L 1852); J. Malcolm.

Inscribed in brown ink in the bottom right-
hand corner: AGOSTIN CARACCIO; and
numbered above in a different hand: *117*.

 This is typical of Agostino's landscape
drawings in pen and ink which, though
stylistically close to those of his brother, are
less direct in handling. The structure of the
landscape, with its obvious demarcation
between foreground, middle ground and
distance, is also inspired by Annibale's
landscape compositions.

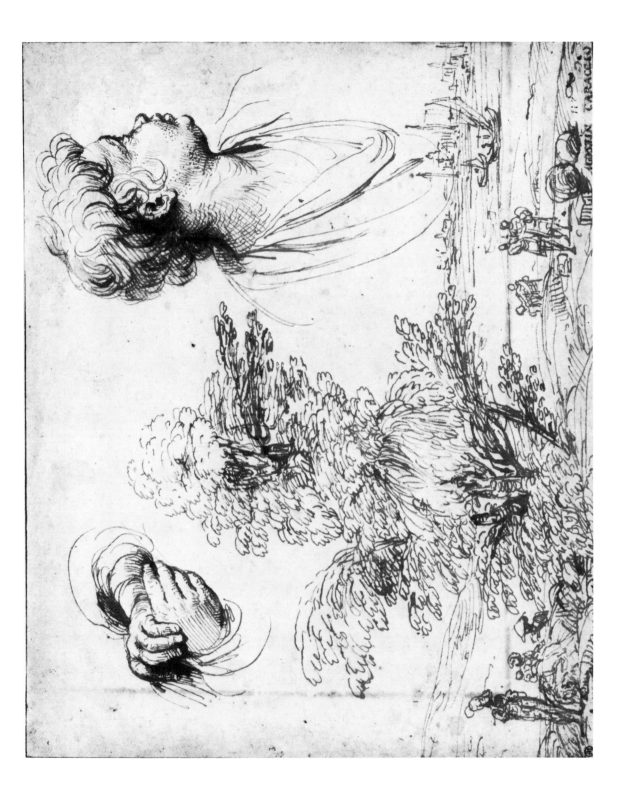

Ludovico Carracci
Bologna 1555-1619

37 *Virgin and Child with Saints*

Pen and brown wash, heightened with white (oxidised), over black chalk.

265 × 193 mm.

1972-7-22-10.

Provenance: J. D. Lempereur (L 1740); Count Moriz von Fries (L 2903); Sir T. Lawrence (L 2445); Lord Francis Egerton, 1st Earl of Ellesmere (L 2710b).

Literature: P. Tomory, *The Ellesmere Collection*, Leicester Museum, 1954, no.4; *Mostra dei Carracci, Disegni* (exh. cat.), Bologna, 2nd edition, 1963, no.17.

Inscribed in black chalk in the lower left-hand corner: *Lodovico Carracci.*

A preparatory study, with considerable variations, for the painting, datable from 1605 to 1608, in the collection of the Marquis of Lansdowne at Bowood.

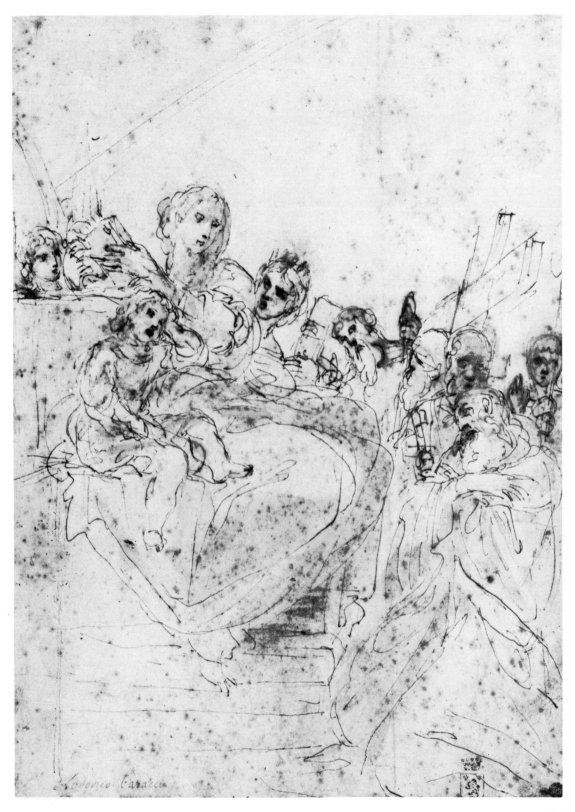

Lodovico Carracci

Ludovico Carracci
Bologna 1555-1619

38 *Vision of St Francis*

Pen and brown wash, heightened with white,
over black chalk on buff paper; squared in
black chalk.

264 × 119 mm.

1977-12-10-2.

Provenance: Sir P. Lely (L2092); R. Houlditch
(L2214, preceded by the number 2, inscribed in
brown ink).

The scene is that of St Francis's thanksgiving
for his miraculous deliverance from the
temptations of luxury. Tradition relates how
one night St Francis, counselled by the devil to
take care of his body, rushed out naked from
his cell and threw himself into a rose bush; the
bush immediately changed into a rose garden
with plants without thorns. In the drawing St
Francis is shown offering roses to Christ and
the Virgin.

No directly corresponding painting is so far
known, though the composition is close to the
Jubilee of the Porziuncola in the Prado,
Madrid (*Pintura Italiana del Siglo XVII*, exh.
cat., Prado, Madrid, 1970, no.40), for which
there is a preparatory study in the Louvre (inv.
no.7707; reproduced in H. Bodmer, *Lodovico
Carracci*, Burg-bei-Magdeburg, 1939, pl.113).

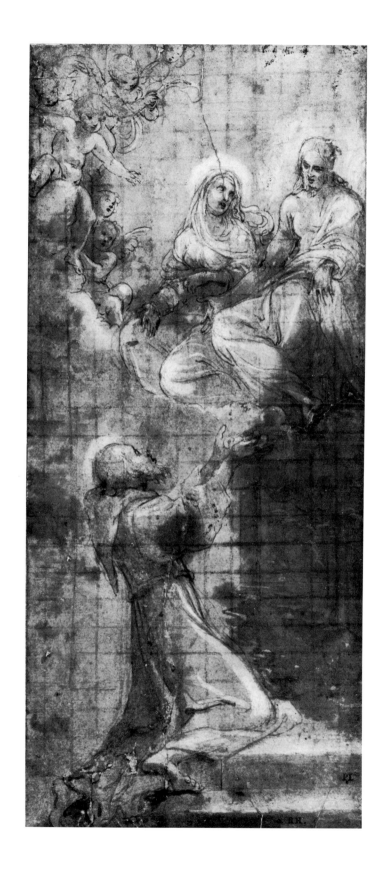

Guido Reni
Bologna 1575-1642

39 *Coronation of the Virgin with four Saints*

Black chalk with brown wash, heightened with
white, on grey-blue paper.

360 × 245 mm.

1946-7-13-237.

Provenance: Sir T. Lawrence (L 2445);
Phillipps-Fenwick; presented anonymously.

Literature: S. Pepper, *MD*, vi, 1968, pp.364ff.

A study for the painter's first public
commission (*c*.1595 to 1598), *Coronation of the
Virgin with four Saints*, painted for S.
Bernardo, and now in the Pinacoteca, Bologna.
Reni, previously trained by the Flemish painter
Denis Calvaert (1540-1619), had transferred to
the Carracci Academy shortly before. This
drawing shows how rapidly he had absorbed
the style of the Carracci.

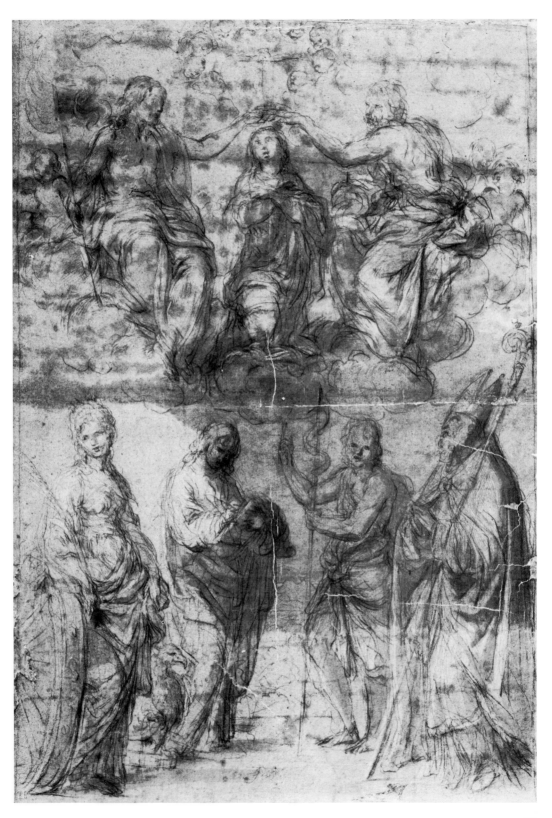

97

Guido Reni
Bologna 1575-1642

40 *Study for the head of St Crispin*

Black, red and white chalk on brown paper.
361 × 231 mm.
Pp. 3-23.
Provenance: Sir J. Reynolds (L 2364); Payne
Knight Bequest, 1824.
Literature: K. T. Parker, *Catalogue of the
Collection of Drawings in the Ashmolean
Museum*, vol.II, Oxford, 1956, p.473.

For the figure of St Crispin in the *Virgin
and Child with Sts Crispian, Crispin and the
hermit Paul*, the altarpiece painted in 1621 for
the church of S. Prospero, Reggio Emilia, and
now in the Gemäldegalerie, Dresden. A more
finished version of the drawing is in the
Kunstmuseum, Düsseldorf (*Meisterzeichnungen
der Sammlung Lambert Krahe*, exh. cat.,
Düsseldorf Kunstmuseum 1964, no.35), and
another in the Nationalmuseum, Stockholm
(inv. no.1863/1074).

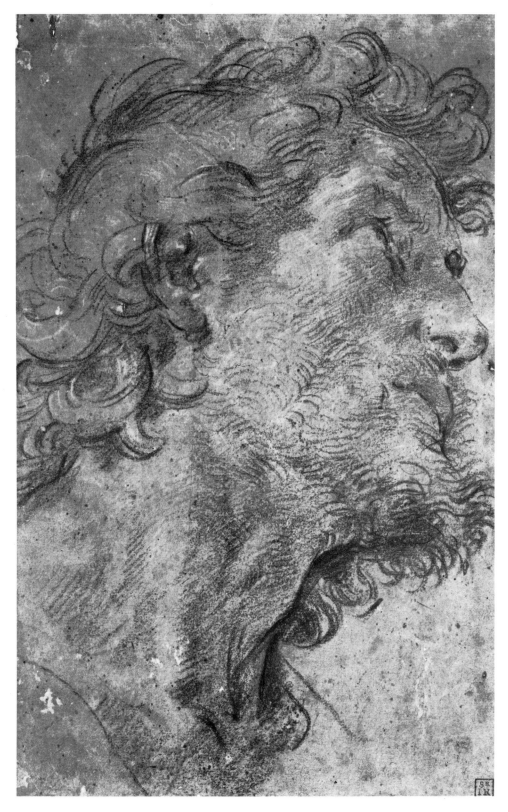

Francesco Albani

Bologna 1578-1660

41 *Death of Adonis*

Pen and brown wash.

189 × 265 mm.

1895-9-15-697.

Provenance: Earl Spencer (L 1531); J. Malcolm.

Literature: Johnston, fig.20.

A late drawing according to Johnston, and
possibly made in connection with a picture
mentioned in the artist's correspondence.
Drawings by Albani, who, particularly at the
end of his career, specialised in the production
of small easel paintings of mythological and
allegorical scenes, are rare. Mostly executed in
pen and wash, they are close in style to those
by Annibale Carracci, his master.

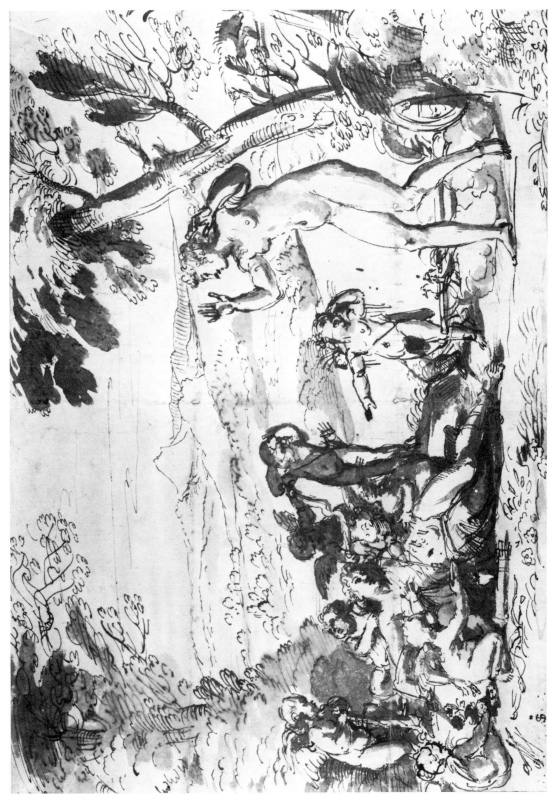

Simone Cantarini
Pesaro 1612 – Verona 1648

42 *The Rape of Europa*

Red chalk.

197 × 272 mm.

1856-7-12-8.

Provenance: J. Barnard (etched in reverse with considerable elaborations by Giuseppe Zocchi in *73 Prints engraved by F. Bartolozzi, &.c. from the original Pictures and Drawings of Michael Angelo; Domenichino; etc.*, published by John and Josiah Boydell, vol.II, London, n.d., pl.55, as '... in the Collection of John Barnard Esq.r').

A study in reverse and with variations for the artist's etching of the subject (B XIX, p.141, no.30). Two other studies for the print exist, one in the Brera, Milan, and the other in the Museo Correr, Venice (cited by M. Mancigotti, *Simone Cantarini il Pesarese*, Pesaro, 1975, p.202).

Giovanni Francesco Barbieri, called
Guercino
Cento 1591 – Bologna 1666

43 *Head of a soldier wearing a helmet*

Black chalk, heightened with white, on buff
paper.

192 × 144 mm; made up with a narrow strip of
paper along the left-hand edge.

1979-10-6-84.

Provenance: R. Joseph.

Mario Di Giampaolo was the first to point out
that this is a study for the head of the soldier,
in armour and holding a staff, who stands at
the extreme left of *St Roch thrown into prison*,
the fresco painted in 1618 in the Oratorio di
S. Rocco, Bologna (reproduced in D. Mahon, *Il
Guercino: Dipinti*, exh. cat., Bologna, 1968,
colour pl. 1, facing p.xlviii). Two composition
drawings, one in the collection of Mortimer
Brandt, New York, and the other in the
Louvre (inv. no.6880), are discussed in
Mahon, *Disegni*, under no.28.

 This is one of the earliest known chalk
drawings by the artist and is of particular
interest since it shows how closely the young
Guercino was inspired by chalk studies by the
two Bolognese painters Pietro Faccini (*c.*1562-
1602) and Giacomo Cavedoni (1577-1660).
Indeed, the attribution of this drawing
alternated for a long time between these two
names.

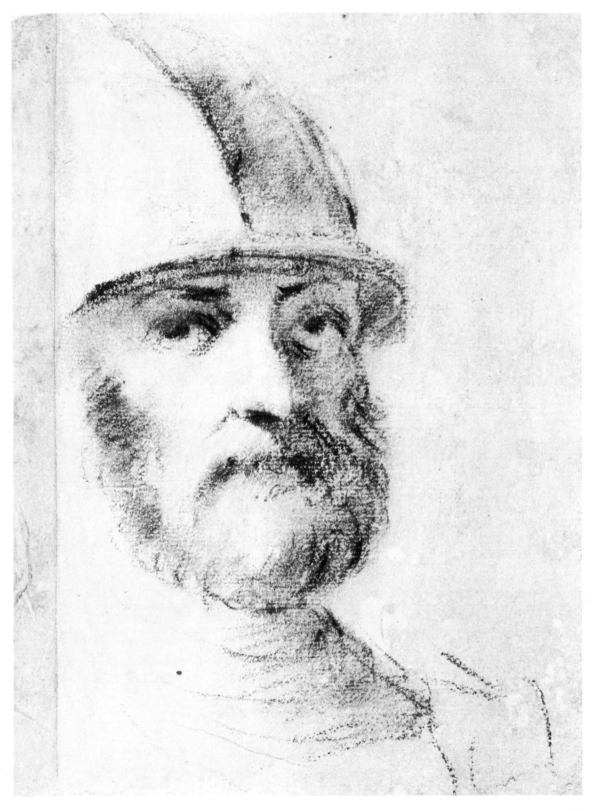

Giovanni Francesco Barbieri, called
Guercino
Cento 1591 – Bologna 1666

44 *Reclining putto*

Red chalk.

153 × 207 mm.

1952-1-21-41.

A study for one of the putti in the frieze
immediately above the gallery in the drum of
the cupola of Piacenza Cathedral (reproduced
in N. Grimaldi, *Il Guercino*, Bologna, 1968 ed.,
pl.155). In 1626 to 1627 Guercino completed
the cupola, begun by Pier Francesco
Mazzucchelli, called Il Morazzone (1573-
c.1626), and painted the walls as far down as
the gallery. An offset of a drawing close to this,
but showing the putto in a slightly different
pose, is at Windsor (inv. no.2973).

 The British Museum also possesses a
drawing (1952-1-21-45) for the putto
immediately to the right of that shown in the
present drawing which, though damaged and
retouched, is probably autograph. An offset of
this second drawing is also at Windsor
(inv. no.2972).

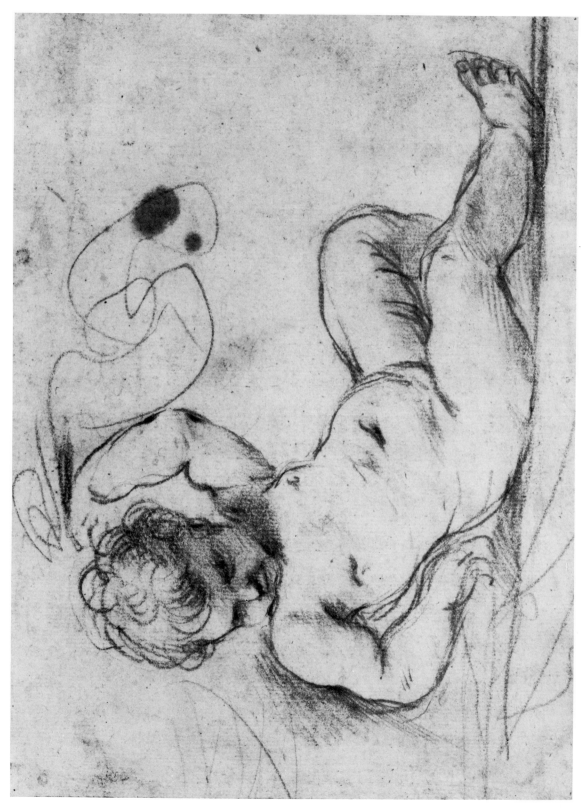

Giovanni Francesco Barbieri, called
Guercino
Cento 1591 – Bologna 1666

45 *Damon and Phythias*

Pen and brown ink with blue-grey wash.
205 × 308 mm.
1969-9-20-17.
Provenance: Mr and Mrs A. Nussbaum, by
whom bequeathed.

Mr Denis Mahon in a letter to the Department
has pointed out that this is a study for a
painting made for Cardinal Palotta, the Papal
Legate to Ferrara, and, according to Guercino's
account book, paid for in May 1632. The
painting is now lost, but a replica exists in the
Palazzo Rospigliosi, Rome.

The scene shows the important episode in
the friendship of the two Pythagoreans Damon
and Phythias, which was to give them fame.
Phythias, wrongly accused of an attempt on the
life of the tyrant Dionysius the Younger, was
condemned to death. Protesting his innocence,
he was given a few days' liberty in which to
arrange for the future care of his family, but
on condition that Damon would act as surety
for his return. When Phythias reappeared at
the appointed time of his execution, the tyrant
was so impressed by his faithfulness that he
requested to be admitted to their friendship.
The drawing would seem to show, to the left,
Damon as Phythias' proxy about to be
executed and, to the right, Phythias returning,
to the astonishment of Dionysius.

Another drawing, slightly closer to the
finished composition, is in the Kunsthalle,
Bremen (inv. no.1953/50).

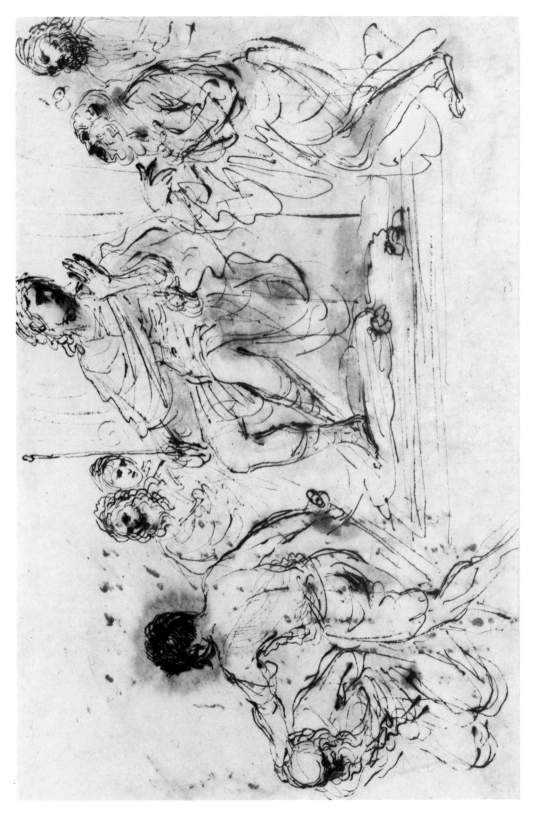

Giovanni Francesco Barbieri, called
Guercino
Cento 1591 – Bologna 1666

46 *Christ appearing to St Theresa*

Pen and brown ink.

353 × 204 mm.

Ff. 2-134.

Provenance: Rev. C. M. Cracherode Bequest,
1799.

Literature: Mahon, *Disegni*, under no.138.

A preparatory study for the altarpiece
commissioned by Barthélemy Lumague in 1634
and, according to Malvasia (*Felsina Pittrice*,
1841, vol.II, p.163), destined for 'the church of
the Scalzi, Lyon, France'. The painting is now
in the Musée at Aix-en-Provence. Other
drawings for the same composition are at
Cento, Windsor, Haarlem and Angers (see
Mahon, *loc. cit.*).

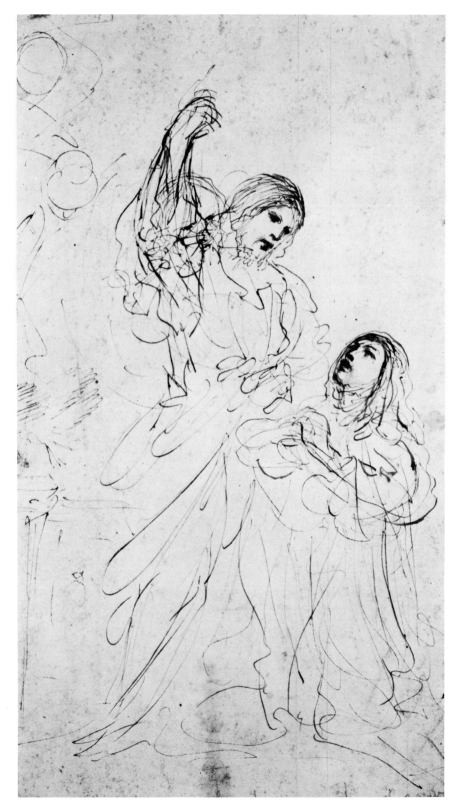

Giovanni Francesco Grimaldi
Bologna 1606 – c.1680

47 *Landscape with two boys leaning over
a pool*

Pen and brown ink.
295 × 418 mm.
At-10-45.
Provenance: Canonico Vincenzo Vittoria; Rev.
C. M. Cracherode Bequest, 1799.

A study for the artist's etching of the subject
(B XIX, p.110, no.45); although the design is in
the same direction as the print, there are
considerable differences of detail. This drawing
is one of 124 by Grimaldi in an album that
once belonged to Canonico Vincenzo Vittoria.

Grimaldi, active in Rome for much of his
career, specialised as a painter of landscapes,
and his work in this genre, with its sense of
carefully organised structure, was clearly
inspired by that of Annibale Carracci.

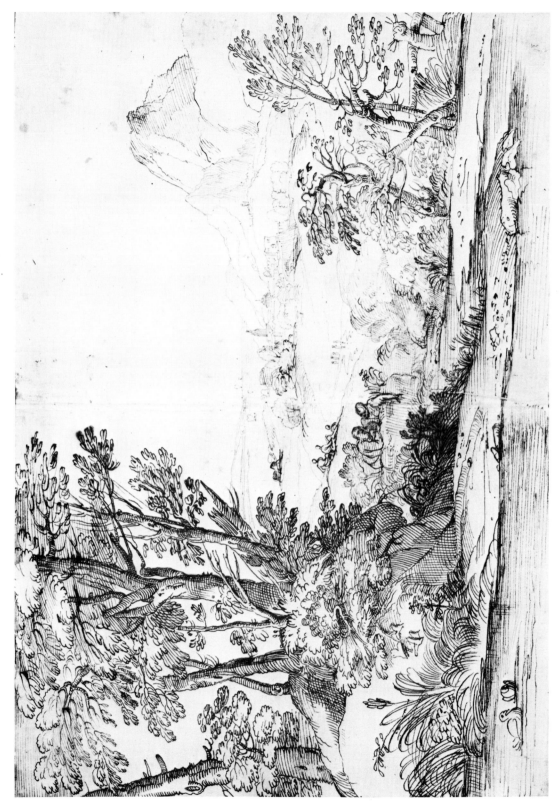

Domenico Maria Canuti
Bologna 1620-1684

48 *Taddeo Pepoli elected Prince*

Red chalk with pink and brown wash on grey
paper.
197 × 297 mm.
1950-6-23-3.
Literature: E. Feinblatt, *Art Quarterly*, xxiv,
1961, p.268; *eadem*, *MD*, viii, 1969, p.165.

A study for one of the medallions painted in
1666 over the stairs in the Palazzo Pepoli,
Bologna. In the fourteenth century Taddeo
Pepoli, an ancestor of the family, was elected
Prince of Bologna.

Two further studies for the fresco are in the
Koenig-Fachsenfeld Collection, now in the
Staatsgalerie, Stuttgart. The first, no.11/545,
like the British Museum drawing, belongs to the
early phase of the design of the composition.
The second, no.370, is a late preparatory study
corresponding in design to the finished fresco.
Preparatory oil *bozzetti* are listed by Feinblatt
and also R. Rolli (*Pittura Bolognese 1650-1800:
dal Cignani ai Gandolfi*, Bologna, 1977, p.239),
who includes a plate of the fresco (pl.8a).

Canuti was the most important Bolognese
painter to practise the Full Baroque style in his
native city. His drawings owe much in style to
those by Ludovico Carracci and Guercino.

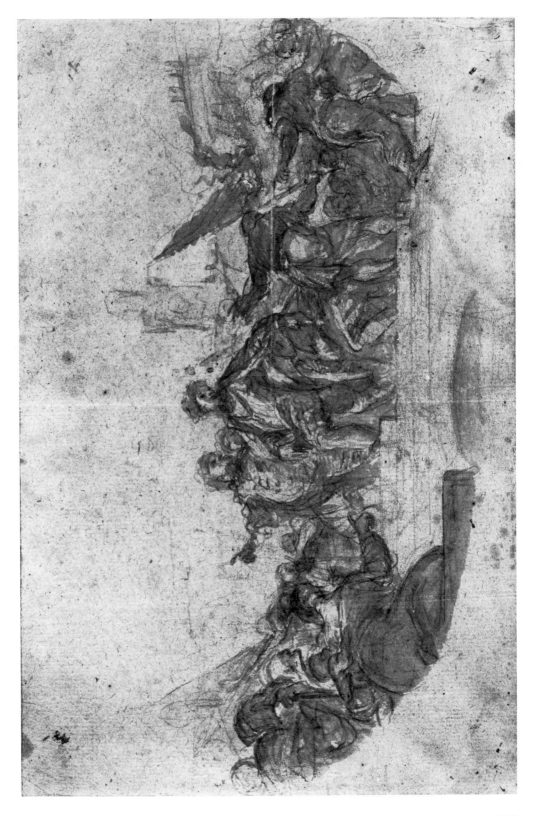

Giuseppe Maria Mitelli
Bologna 1634-1718

49 *Study for the print 'The numerous company of the ruined'*

Red chalk.

247 × 415 mm.

1899-7-29-2.

Provenance: L. Binyon, by whom presented.

Inscribed in brown ink in the bottom left: *Mitelli*; numbered in red chalk above each of the figures, with the exception of the two to the left: *17, 16, 15, 14*.

This is a preparatory study in reverse for the right-hand section of the print *Questa è la numerosa compagnia de Ruvinati* (B XIX, p.286, no.40; A. Bertarelli, *Le incisioni di G. M. Mitelli*, Milan, 1940, no.493). Inscriptions on the print identify the figures. 'Poverty' leads the procession, with behind her 'Calamity or Misery' holding a frond with empty purses tied to it upside down. Then follow the members of the company reduced to misery: 'For the high rents which never bring prosperity' (17), 'For continuous illness' (16), 'For being burdened with children and family' (15), 'Whosoever gives credit is reduced to this' (14). A study for the left-hand section is also in the Collection (1899-7-29-1).

Mitelli specialised in the making of popular prints and was much influenced by Annibale Carracci's paintings and drawings of genre subjects.

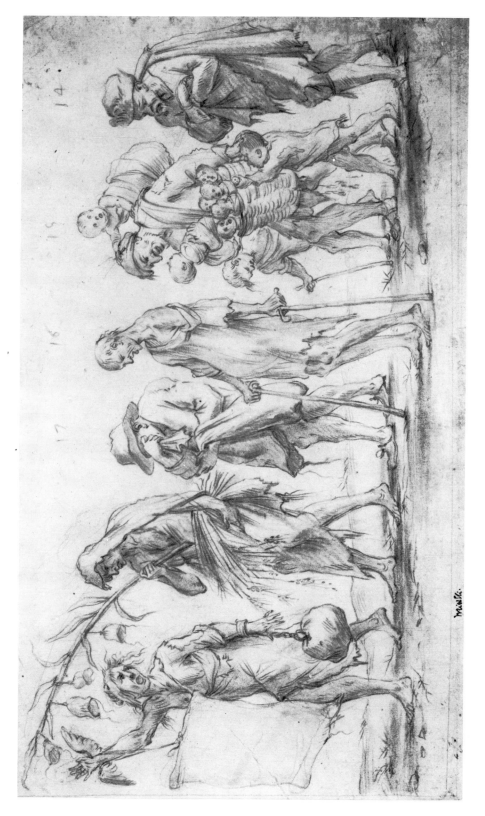

Florentine Drawings

Stefano della Bella
Florence 1610-1664

50 *A Fury*

Pen and brown ink with pink and grey wash over black chalk.

270 × 190 mm; made up with a strip of paper at the top and bottom edges.

1887-5-2-59.

Provenance: Cardinal Giovanni Carlo de'Medici; the Doni family; T. Gibson-Craig.

Literature: P. Dearborn Massar, *MD*, viii, 1970, p.264.

Inscribed in brown ink at the top left: *Furia Per Ballo*; beneath the right arm of the figure: *Tocca di Rame/Nera*; and in the top right numbered: *8*.

One of a group of costume designs by Stefano della Bella in the British Museum for the ballet of the Furies which occurred at the end of Act 1 in the opera *Hipermestra* and was performed by the Accademia degli Immobili in Florence in June 1658.

Carlo Dolci
Florence 1616-1686

51 *Hand holding the Sacred Heart*

Black and red chalk.
186 × 121 mm; lower left-hand corner made up.
1917-6-9-65.
Provenance: J. P. Zoomer (L 1511);
H. L. Wallerstein-Schloss, by whom presented.
Literature: C. McCorquodale in *Kunst des Barock in der Toskana*, Munich, 1976, p.320.

Inscribed in brown ink in the lower right-hand corner: *Carlo Dolci*.

 This drawing was identified by the late Lord Crawford as a study for a picture of *Charity* in his own collection (reproduced in *Apollo*, xcvii, 1973, p.486, pl.13). Another version of the painting was recently on the art market in Florence (reproduced in Sotheby's catalogue, Palazzo Capponi, 23.v.79, lot no.1023).

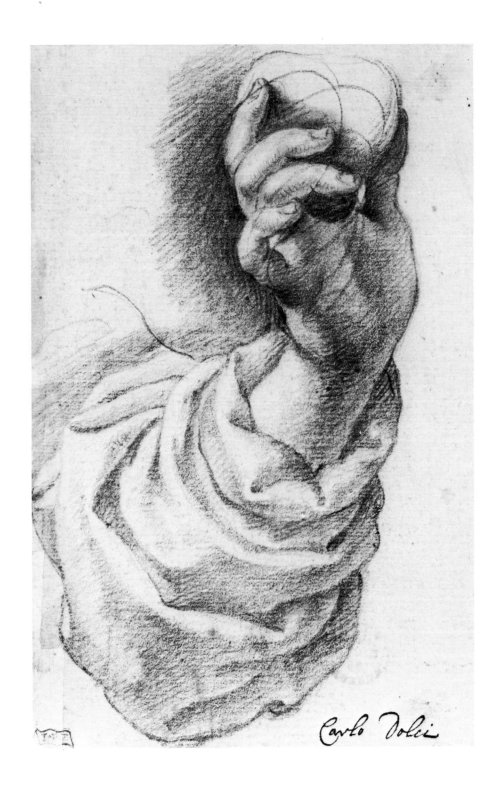

Carlo Dolci

Carlo Dolci
Florence 1616-1686

52 *Self-portrait*

Black and red chalk.

279 × 203 mm.

1899-9-15-577.

Provenance: Earl Spencer (L 1530); J. Malcolm.

Literature: *Portrait Drawings* (exh. cat., British Museum), London, 1974, no.136.

A comparison of the features of the sitter in this drawing with those of Dolci himself in his painted self-portrait in the Uffizi, Florence (reproduced in *Apollo*, xcvii, 1973, p.486, pl.12), supports the conclusion that this too is a self-portrait.

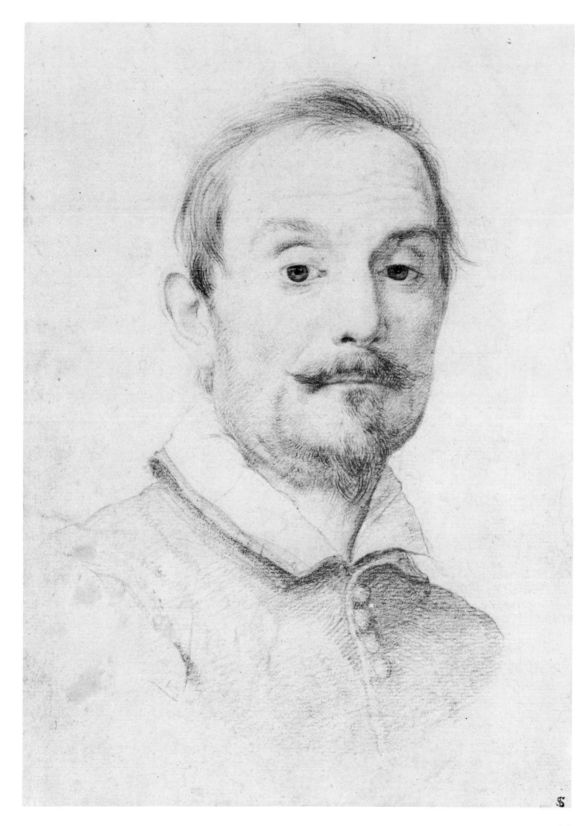

Baldassare Franceschini, called
Volterrano
Volterra 1611 – Florence 1689

53 *Truth unmasking Falsehood*

Black chalk with grey wash, heightened with
white (oxidised).
313 × 175 mm; octagonal.
1955-5-2-1.
Provenance: C. R. Rudolf, by whom presented.

Inscribed in brown ink in the bottom centre:
Volterrano; and numbered in red chalk: *122*.
 This is a composition study for *Truth
unmasking Falsehood*, one of the five scenes
glorifying Vittoria della Rovere, wife of
Ferdinand II de' Medici, which decorate the
ceiling of the Sala delle Allegorie in the Palazzo
Pitti, Florence. A preparatory study for the
figure of Falsehood is in the Uffizi, Florence
(inv. no.3225-s).
 Composition studies for the other scenes
include one in the Pierpont Morgan Library
(Scholz Collection) for the central scene,
*Fortitude, holding an oak, accompanied by
Victory* (J. Bean and F. Stampfle, *The
Seventeenth Century in Italy*, exh. cat.,
Metropolitan Museum of Art and the Pierpont
Morgan Library, New York, 1967, no.97); and
another in the Uffizi (inv. no.3262-s), for *Peace
sets fire to arms*.

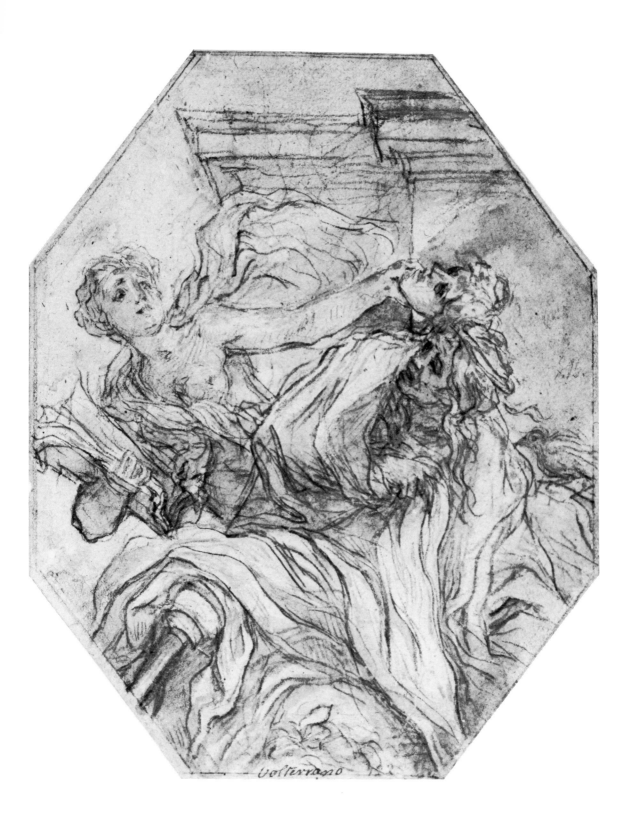

Baldassare Franceschini, called Volterrano

Volterra 1611 – Florence 1689

54 *Martyrdom of St Lucy*

Brush drawing in grey wash, heightened with white, over black chalk underdrawing; border ruled with red chalk.

695 × 471 mm; on two pieces of paper joined horizontally across the centre.

1938-5-14-3.

Provenance: N. Gabburri; J. Malcolm.

Inscribed in the margin below, in brown ink, in a manner characteristic of many drawings with a Gabburri provenance: *Disegno originale di Baldassar Franceschini d[etto] il Volterrano, fatto p[er] la Tavola di S. Lucia, posta nella Capella de SS. Marchesi Albizzi in S. Pier Maggiore della Città di Firenze.*

As Pouncey has observed (note on the mount), the painting for which this drawing is a study is now in the church of S. Paolino, Florence. The inscription below the drawing indicates that this was formerly in S. Pier Maggiore which, except for its lower façade, was demolished in 1784 because of its dangerous condition; the paintings with which it was once adorned were removed beforehand and some can be traced to other churches in Florence, though the majority have since found their way to European and American galleries.

A drawing for the saint and her executioner was recently on the London art market (reproduced in Christie's catalogue, 29.xi.1977, lot no.66). A study for the saint's head and right hand is in the Uffizi, Florence (inv. no.3418-s).

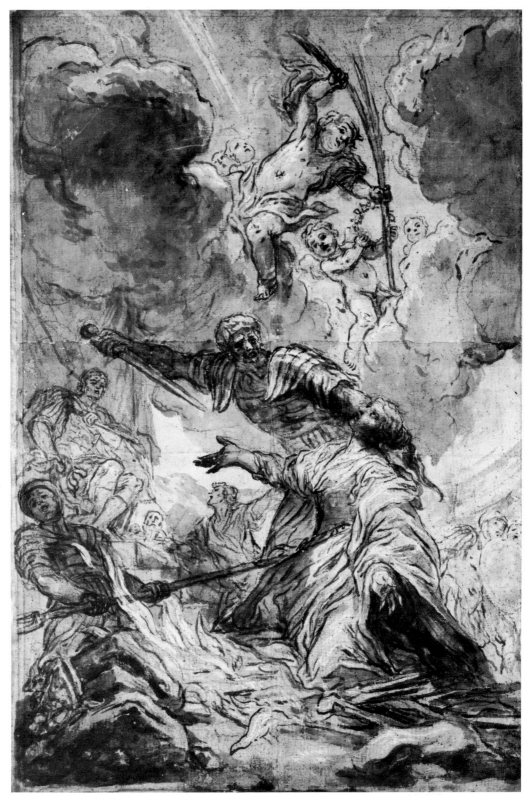

Antonio Domenico Gabbiani

Florence 1652-1726

55 *Study for a figure of Noah; study of his right hand*

Black chalk, heightened with white, on grey paper.

265 × 390 mm.

1978-5-20-10.

For the figure in the cupola fresco of
S. Frediano in Cestello, Florence, painted by
Gabbiani in 1701 to 1718. Besides revealing an
obvious debt to Pietro da Cortona, the drawing
also shows the influence of Carlo Maratta.

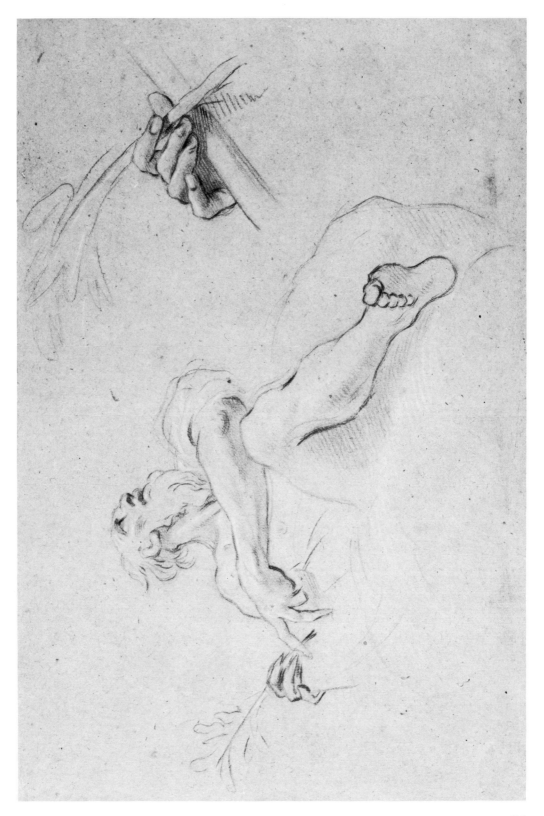

129

Genoese Drawings

Giovanni Benedetto Castiglione
Genoa *c*.1610 – Mantua 1663/5

56 *Sacrifice of Noah*

Brush drawing in oil colour on buff paper,
prepared light brown.
381 × 515 mm.
1887-6-13-75.
Provenance: Conte di Bardi (L 336).
Literature: A. Percy, *Giovanni Benedetto
Castiglione* (exh. cat., Philadelphia Museum of
Art), 1971, no.91.

A typical example of Castiglione's highly
individual technique of brush drawing in oil
colour on paper. It is close in style and design
to a painting of the subject, dated 1659, in a
private collection in Genoa (reproduced in
Percy, fig.31). The composition was possibly
inspired by a painting, now lost, by Nicolas
Poussin.

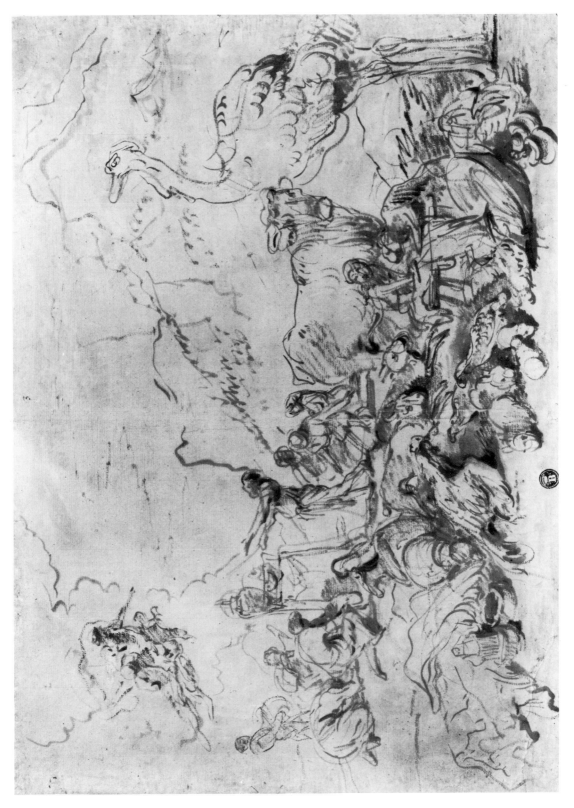

131

Domenico Piola
Genoa 1628-1703

57 *Allegory of Winter*

Pen and brown wash over black chalk.
436 × 301 mm.
1950-11-11-27.
Provenance: R. von Audenaerd; R. Hilditch.
Literature: R. Malagoli, *Burl. Mag.*, cviii, 1966,
p.507.

For the fresco *Winter*, probably painted before
1679, in the Palazzo Rosso, Genoa. The
composition shows, above, personifications of
the Winds and, below, an old man warming
himself beside a fire. A more finished study is
in the Galleria di Palazzo Rosso, Genoa
(inv. no.4485: Malagoli, pp.507-8, fig.25).

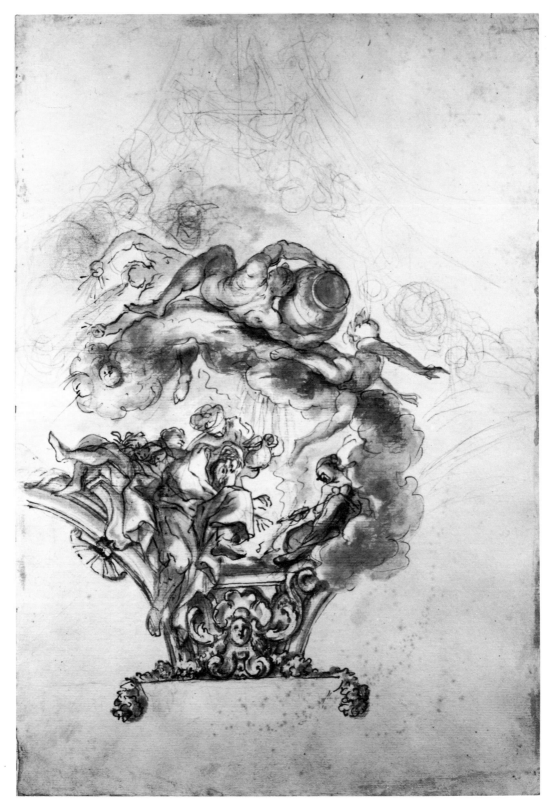

Venetian Drawings

Giulio Carpioni
Venice 1611 – Verona 1674

58 *Nymph, satyr and putti*
Black chalk.
298 × 212 mm.
1952-1-21-17.
Provenance: Lord James Cavendish;
L. Colling-Mudge.

Carpioni specialised in small-scale easel
pictures of mythological and allegorical
subjects which he painted with a brightly
coloured palette. His classical style, strongly
inspired by the work of Poussin and Testa,
contrasts with the more painterly Baroque of
his Venetian contemporaries. Carpioni's
drawings are uncommon. This is a good
example of one of his more finished studies. It
was previously attributed to the French painter
Simon Vouet (1590-1649).

Erratum

Since going to press it has been discovered that
no. 58 is not by Giulio Carpioni but by the
French painter and engraver Michel Dorigny
(1617–1665) and is a preparatory study in
reverse and with differences for his print of this
subject. This is described by A.-P.-F. Robert-
Dumesnil, *Le Peintre-Graveur Français*, vol. iv,
Paris, 1839, p. 253, no. 10, and bears the
inscription, lower left: *M. Dorigny. invent. et
fecit*; it is one of a set of prints of Bacchanalia.
A drawing formerly at Colnaghi's wrongly
attributed to Carpioni (P. and D. Colnaghi and
Co. Ltd, *Art in seventeenth-century Italy*, exh.
cat., London, spring 1972, no. 167) and
another sold at Christie's attributed to the
circle of Simon Vouet (reproduced in Christie's
catalogue, 29.xi.77, lot 183) are by the same
hand and *en série* with no. 58.

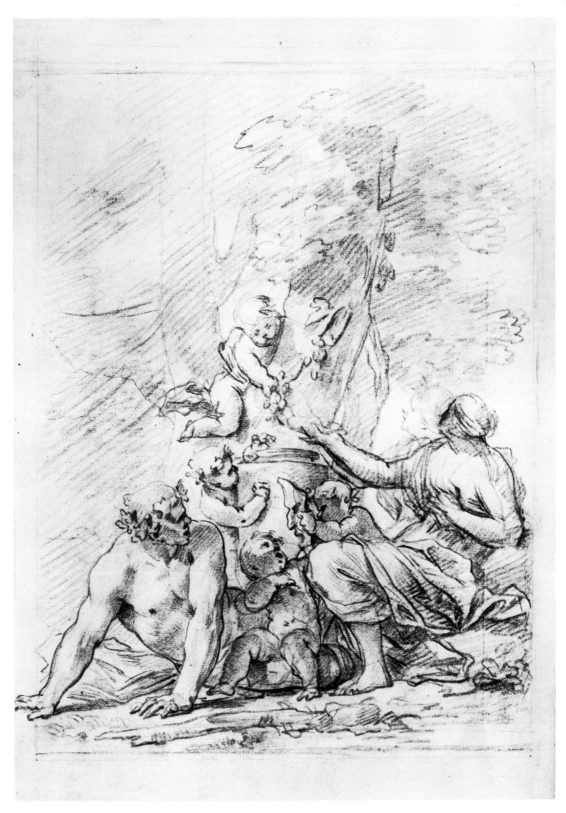

Pietro Liberi
Padua 1614 – Venice 1687

59 *Two studies for a group of Mars,*
Venus and Cupid

Pen and brown ink over black chalk.
194 × 228 mm.
1874-8-8-34.

A characteristic drawing by Liberi. Its purpose
is not yet known.

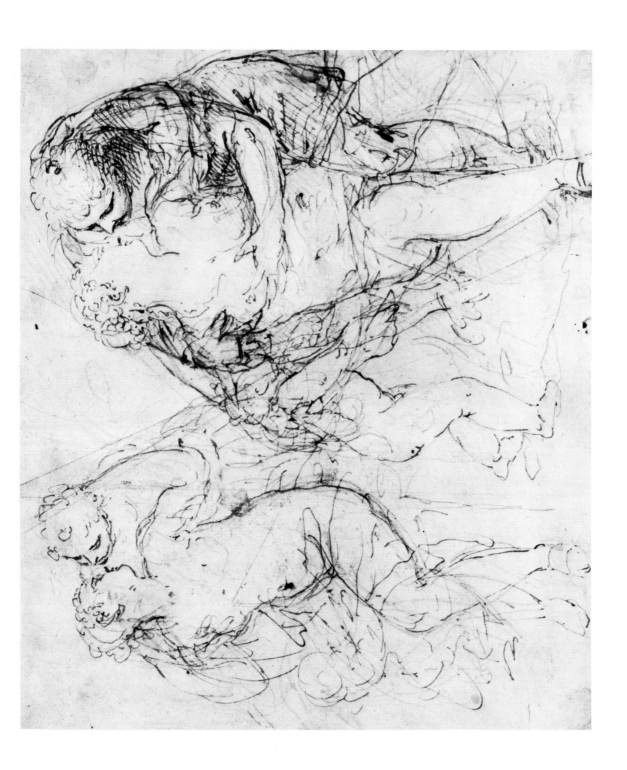

137

Neapolitan Drawings

Giuseppe Ribera
Valencia 1590 – Naples 1652

60 *St Albert tied to a tree*

Red chalk.

232 × 170 mm.

1850-7-13-4.

Literature: J. Brown, *Jusepe de Ribera* (exh. cat.), Princeton, 1973, pp.159f., no.9.

Signed and dated in red chalk: *Jusepe de / ribera fe.t / 1626.*

 This sheet, which belongs to the category of Ribera's finished red chalk studies, is important since it is dated and therefore allows a group of similar drawings to be placed at the same time. The handling of the chalk is typical of Ribera's drawings of this type, and the elongated form of the figure is also characteristic.

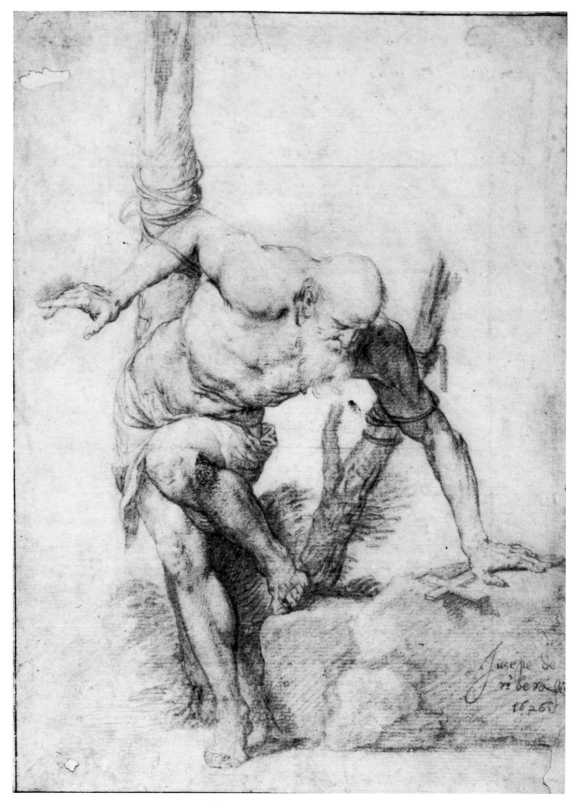

139

Salvator Rosa
Naples 1615 – Rome 1673

61 *Judah and Tamar*

Pen and brown ink.
147 × 103 mm.
Ff. 2-167.
Provenance: J. Richardson, sen. (L 2183);
T. Hudson (L 2432); Rev. C. M. Cracherode
Bequest, 1799.
Literature: M. Mahoney, *The Drawings of
Salvator Rosa*, New York and London, 1977,
vol. I, p.633, no.72.1.

A preparatory drawing for the recently
discovered painting of this subject now in the
possession of a London collector (reproduced
in Christie's catalogue, 30.iii.79, lot 20). The
story of Judah and Tamar is related in Genesis
38. The connection between painting and
drawing and the identification of the subject
(the drawing was previously thought to
represent *Noli me tangere*) were made by the
owner in a letter to the Department.

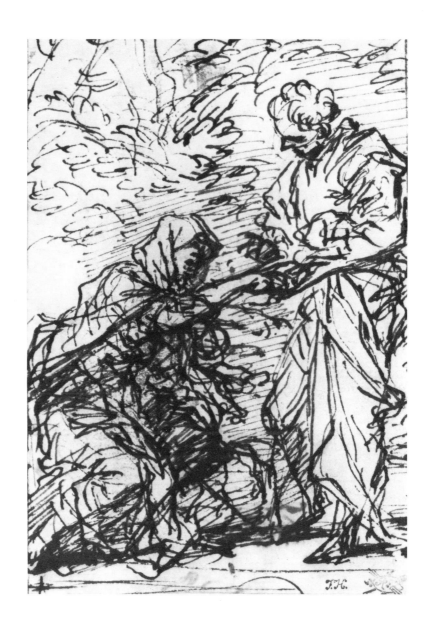

Salvator Rosa
Naples 1615 – Rome 1673

62 *Plato's Academy*

Pen and brown ink with red and black chalk.

422 × 272 mm.

1855-7-14-54.

Literature: L. Salerno, *Salvator Rosa*, Florence, 1963, p.128, no.59; M. Mahoney, *The Drawings of Salvator Rosa*, New York and London, 1977, vol.I, pp.572f., no.65.20.

Inscribed in brown ink in the lower right-hand corner: *Rosa*.

A preparatory drawing, in reverse and with substantial differences, for the artist's etching of the subject (B XX, p.269, no.3) which can be dated *c*. 1662. Other drawings for the same print are listed by Mahoney.

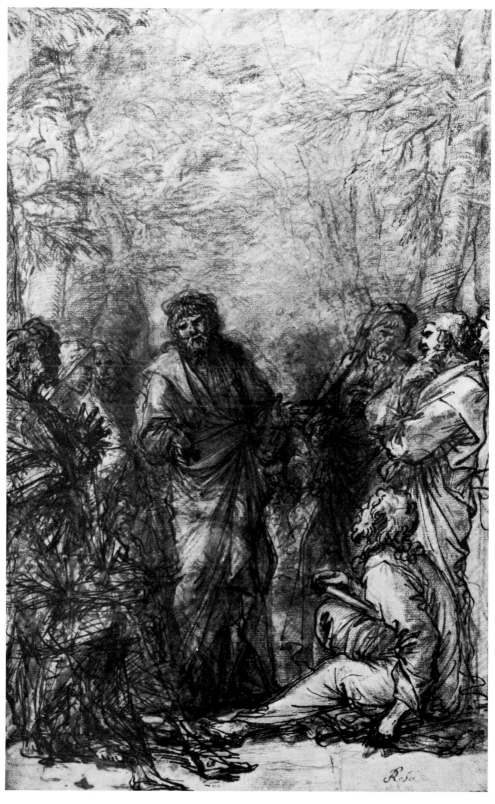

Mattia Preti

Taverna 1613 – La Valletta 1699

63 *Man carrying a barrel; man carrying a cage; and man carrying a dish*

Red chalk.

385 × 274 mm.

1874-8-8-45.

Literature: W. Vitzthum, *Le Dessin à Naples du XVIe Siècle au XVIIIe Siècle* (exh. cat., Cabinet des Dessins, Musée du Louvre) Paris, 1967, p.35, under no.65; K. Andrews, *Catalogue of Italian Drawings, National Gallery of Scotland*, Cambridge, 1968, p.99, under no.D 2249.

The principal study, a man carrying a barrel, is for the figure in the left foreground of *The Pope, inspired by the Holy Ghost, receives Homage from the Ecclesiastical Orders*, the altarpiece painted in *c*.1675 for the church of S. Domenico, Siena. Another drawing for the same figure is in the National Gallery of Scotland, Edinburgh (see K. Andrews). The two other studies are for figures which do not appear in the painting but which may have been intended for it in an early phase of preparation.

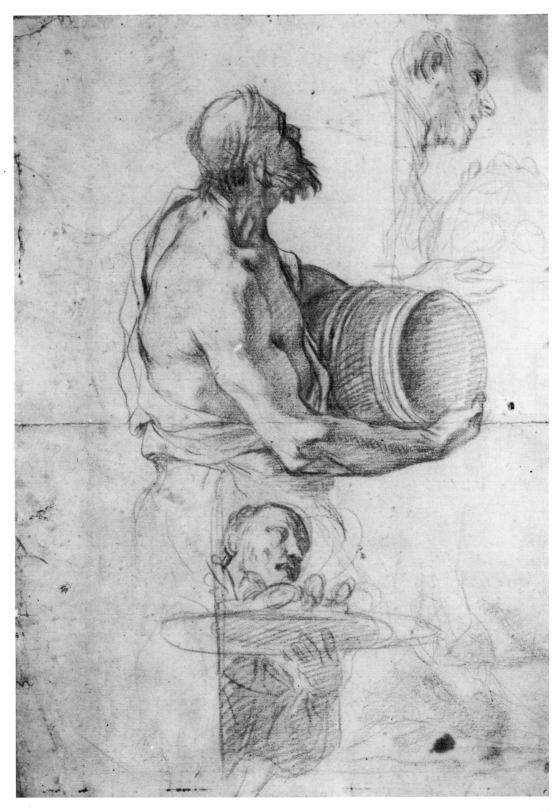

Luca Giordano
Naples 1634 – 1705

64 *Standing man seen from the rear*

Red chalk on paper washed light red.
319 × 180 mm.
1920-4-20-8.
Literature: N. Turner, *MD*, xiv, 1976, p.386.

A typical example of the highly finished red
chalk drawings in the style of Ribera which
Giordano made after the works of Roman
masters during his first visit to Rome in the
early 1650s. The figure is copied from one of
the scenes painted by Polidoro da Caravaggio
on the façade of the Palazzo Milesi in the early
part of the previous century.

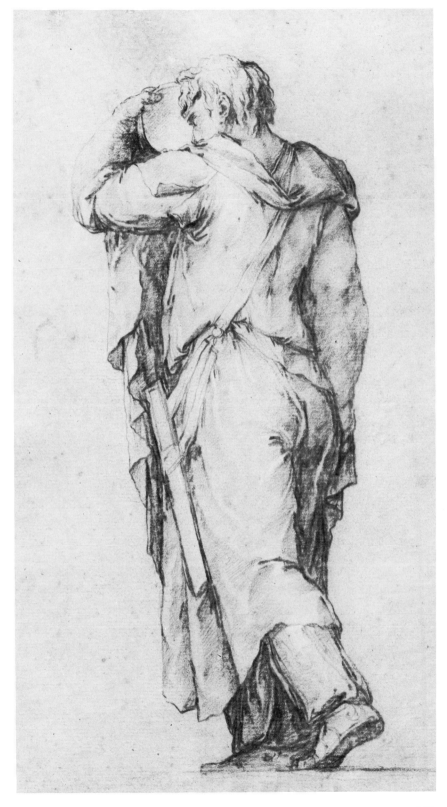

Luca Giordano
Naples 1634-1705

65 *Miracle of St Anthony of Padua*

Black chalk and grey wash.

302 × 382 mm.

1950-11-11-6.

Literature: O. Ferrari, *Burl. Mag.*, cviii, 1966, p.298; O. Ferrari and G. Scavizzi, *Luca Giordano*, Naples, 1966, vol.II, p.255.

Inscribed in black chalk below the two seated figures in the lower part of the drawing, evidently in the artist's hand: *esperienza* and *verita*.

A preparatory study for one of the frescoes in S. Antonio de los Portugueses, Madrid; Giordano decorated this church between 1692 and 1702.

149

List of works referred to in abbreviated form

B Adam Bartsch, *Le Peintre Graveur*, 21 vols, Vienna, 1803-21.

Blunt and Cooke Anthony Blunt and Hereward Lester Cooke, *The Roman Drawings of the XVII and XVIII Centuries in the Collection of Her Majesty the Queen at Windsor Castle*, London, 1960.

Burl. Mag. *Burlington Magazine*, London, from 1902.

Graf, 1973 Victoria and Albert Museum and Scottish Arts Council, *Master Drawings of the Roman Baroque from the Kunstmuseum Düsseldorf* (catalogue and introduction by Dieter Graf), exhibition catalogue, London and Edinburgh, 1973.

Graf, 1976 Dieter Graf, *Die Handzeichnungen von Guglielmo Cortese und Giovanni Battista Gaulli*, Kataloge des Kunstmuseums Düsseldorf, Serie III, Band 2/1, Düsseldorf, 1976.

Harris and Schaar Ann Sutherland Harris and Eckhard Schaar, *Die Handzeichnungen von Andrea Sacchi und Carlo Maratta*, Kataloge des Kunstmuseums Düsseldorf, Serie III, Band 1, Düsseldorf, 1967.

Johnston Catherine Johnston, *Il Seicento e il Settecento a Bologna*, I Disegni dei Maestri: Fratelli Fabbri Editori, Milan, 1970.

L Frits Lugt, *Les Marques de Collections de Dessins et d'Estampes*, Amsterdam, 1921.
L Suppl. Supplementary volume, The Hague, 1956.

Mahon, *Disegni* *Il Guercino. Disegni*, compiled by Denis Mahon, exhibition catalogue, Bologna, 1969.

MD *Master Drawings*, New York, from 1963.

Popham, *Fenwick* A. E. Popham, *Catalogue of Drawings in the Collection formed by Sir Thomas Phillipps, Bart., F.R.S., now in the Possession of his Grandson, T. Fitzroy Phillipps Fenwick*, Cheltenham, privately printed, 1935.

Vitzthum Walter Vitzthum, *Il Barocco a Roma*, I Disegni dei Maestri: Fratelli Fabbri Editori, Milan, 1970.

Index of Artists

The numbers refer to plates and not to pages.